Cywaith Cymru . Artworks Wales is the national organisation for public art in Wales. It is a registered charity and a company limited by guarantee. It receives revenue funding from the Arts Council of Wales as well as grant funding for the Artist-in-Residence programme.

Established in 1981 as the Welsh Sculpture Trust to encourage the placing of art in the environment through commissions, exhibitions and residencies, the organisation has evolved and grown over the years. As its remit widened to cover the spectrum of visual arts activity including architecture and design, in 1991, renamed Cywaith Cymru . Artworks Wales, it took over the work of the Welsh Arts Council's Commissions service. A further important development took place in 1998, when Cywaith Cymru was invited to develop a new national Artist-in-Residence programme by the Arts Council of Wales. It is constantly reviewing and challenging the parameters of practice, not only in public art, but across the whole of the visual arts.

The wide range of work covered by the organisation is supported by a strong commitment to the cultural life of Wales, seeking to bring about new work which is particular to its environment and which reflects the culture from which it comes.

Cywaith Cymru holds a unique position as a public art organisation in Britain, being one of the longest established, as well as having a leading role as an innovator and catalyst within the field. It is particularly concerned with cultural issues related to history, language and a sense of place, and works across art forms with visual artists, poets, musicians and performance artists.

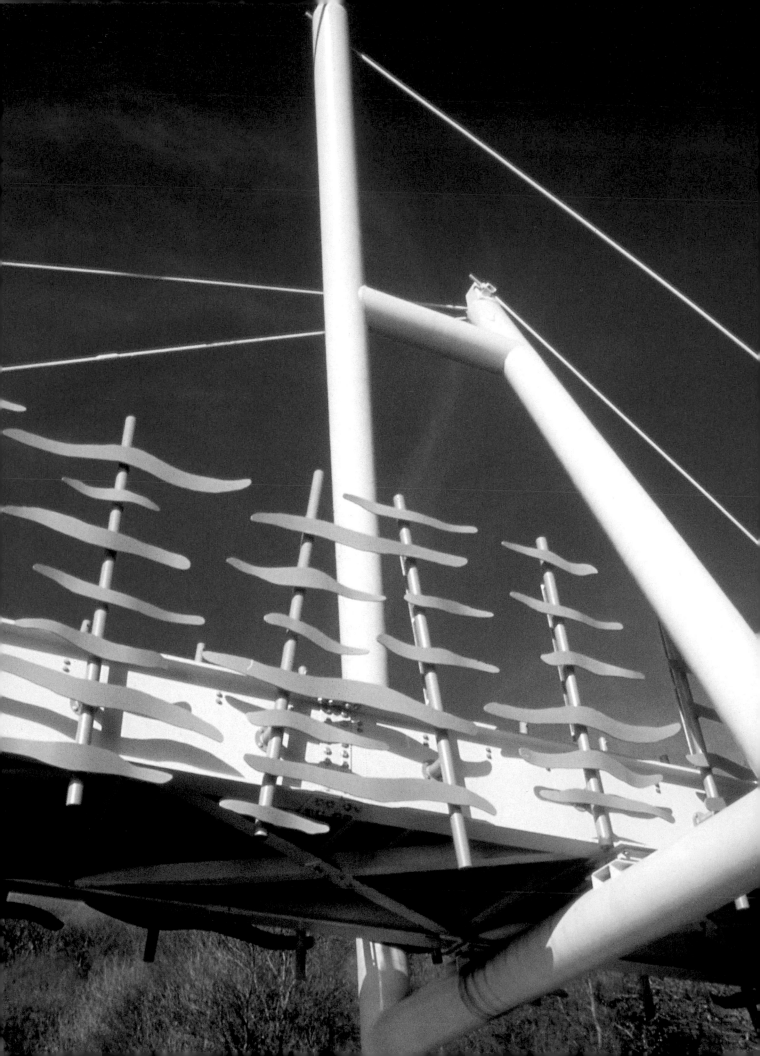

GROUNDBREAKING

the artist and the changing landscape

edited by Iwan Bala

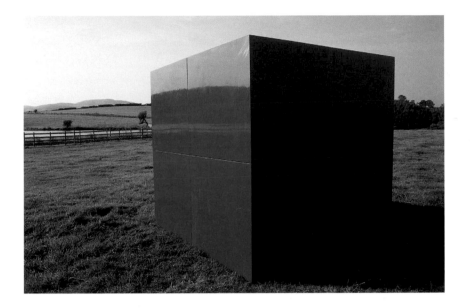

seren

cywaith cymru | artworks wales

This book is published by Seren in collaboration
with Cywaith Cymru . Artworks Wales

Seren is the book imprint of
Poetry Wales Press Ltd
57 Nolton Street, Bridgend, Wales CF31 3AE

Cywaith Cymru . Artworks Wales
Crichton House, 11-12 Mount Stuart Square
Cardiff CF10 5EE

First published in 2005
ISBN 1-85411-341-0
A CIP record for this title is available from the British Library

The publisher works with the financial assistance of the
Welsh Books Council

Printed in Frutiger by Gwasg Gomer, Llandysul

Front cover image:
Philippa Lawrence, 'Bound'
EXPLORATIONS 2003,
National Botanic Garden of Wales
Photo: Philippa Lawrence

Page 2:
Jon Mills, Dyfi Millennium Bridge
Machynlleth 2001
Engineer: Bruce Pucknell
Photo: Simon Fenoulhet

Page 3:
Dylan Wyn Jones, 'The Blue Cube'
GWREIDDIAU/ROOTS
National Eisteddfod, Y Bala 1997
Photo: Martin Roberts

contents

Meical Watts
Cyfrifoldeb/Responsibility
Parc Glynllifon Drama Site 1990

acknowledgements

Small arts organisations depend for their success on alchemy – a mixture of stimulating ideas and energy brought together through collaboration. Cywaith Cymru has always benefited from the immense dedication of its Council members and staff and, in the early days of the Welsh Sculpture Trust, an active membership, spread across the whole of Wales. It was through this membership that the organisation originally found its roots, in particular through the founders, the artist and writer Shelagh Hourahane, Bruce Griffiths QC, the architect Sir Alex Gordon, Peter Griffiths QC and the artists Harvey Hood and Peter Nicholas. The Welsh Sculpture Trust quickly established itself as a catalytic organisation, willing to take risks, open to the new and innovative.

Over a period of nearly twenty-five years, the organisation has developed an exceptional network of friends and collaborators, who include people from every part of Welsh life; politics, local government, education and the arts. It would be impossible to name all who have contributed to our work, but we must remember certain individuals who opened our eyes to long-lasting principles. The late Ioan Bowen Rees, former Chief Executive of Gwynedd and initiator of the Writers of Gwynedd project at Parc Glynllifon, had a very special understanding of how cultural intervention across art forms could transform people's lives. His vision for the Writers of Gwynedd project was translated by Peter Lord and Delyth Prys in 1986 into a blueprint for collaboration between artists, architects, and landscape architects in celebration of the culture.

The artist Paul Davies had a profound affect on all his students and was an enormous influence in the field of public art. He was a radical, a shaper, a true collaborator, passionate about his country and dedicated to working with lay people. This book is dedicated to all the artists who have contributed in such brilliant and imaginative ways to the lives of so many people of different ages and groups. Their extraordinary energy and determination has been a constant source of inspiration. There is often a strange symmetry in life. As we complete this book, the artist Gordon Young, first Director of the Welsh Sculpture Trust, who organised the first major outdoor exhibition of sculpture at Margam in 1981, is now completing a large commission managed by Cywaith Cymru, to celebrate the opening of the National Waterfront Museum, Swansea.

There are so many colleagues inside and outside Cywaith Cymru who have contributed to the continuing dynamic of the organisation, but I would like to pay particular tribute to Simon Fenoulhet, Nia Roberts and Lisa Ricketts who, in their special ways, brought a whole new dimension to our work. I would like to thank the contributors to this book, with whom I have enjoyed an exceptionally lively dialogue over the years and special thanks to Mick Felton and Simon Hicks of Seren for their patience.

Tamara Krikorian, Director
Cywaith Cymru . Artwork Wales
September 2005

Paul Beauchamp

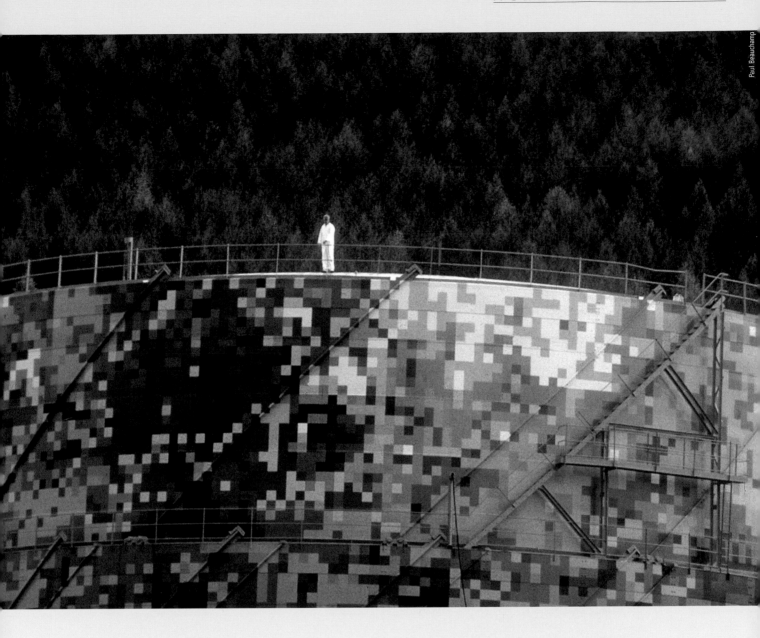

Andrew Cooper
Gas holder, 1993
Llwynypia

foreword

iwan bala

THE TERM 'PUBLIC ART' SIGNIFIES different things to different people. Working for Cywaith Cymru has made me realise that it encompasses much more than commissioned sculpture in a hypothetical 'public plaza'. It is an engagement between the public and art, outside the rarefied confines and contemplative spaces of galleries. It is about collaborations between artists and the community at large.

The landscape around us, both urban and rural, is constantly changing, and so is art. In recent years conceptual practice in 'gallery' art has entered into the discourse of public art, as did abstraction before it. We no longer take it for granted that art in public places necessarily means a monumental sculpture or a mural, although in some very successful cases it still does. The expanding choice of artists' methods and materials has led to an ever-growing variety and inventiveness in urban and rural public art. This is all the more surprising since the work is seldom free of external constraints. To put it simplistically, unlike 'gallery artists', the 'public artists' need to work to a brief other than their own and are influenced by a variety of considerations that extend beyond the purely aesthetic.

Consultation with the public and their elected representatives is an important factor that influences the artists' work. Planning permission, safety regulations and other sundry considerations collude in the creative process. There is now a growing number of artists who are adept at creativity under these conditions. Despite the often negative reportage of the tabloid and local press, people are generally accommodating of challenging projects and schemes in their environment, provided that these projects are seen to be inclusive.

Cywaith Cymru's work over the last quarter century has been 'groundbreaking' in more ways than one. It was, as the Welsh Sculpture Trust, instrumental in advancing the concept of art outside the gallery. As Cywaith Cymru . Artworks Wales, it has created a professional, structured procedure by which the artist could engage with commissioning bodies and later, with residencies. 'Cywaith' translates into English as a collaborative or complete work, a composition. It is as an overall composition that Cywaith Cymru has operated as a body, enabling, as Tamara Krikorian suggests in her essay, other people's dreams to become reality. Tamara Krikorian and Simon Fenoulhet both deserve the credit for creating the culture of this organisation. Both came to the job as practising artists, and over the years many other artists, including the Residencies Manager, Stephen West and myself, have been employed directly as administrators in the office. This has meant that Cywaith has maintained a 'grass roots' level of empathy with the artists they engage with. 'Public Art' as a result, has infiltrated all areas of Wales' cultural

Angharad Pearce Jones
Hadau/Seeds
GWREIDDIAU/ROOTS
National Eisteddfod
Y Bala 1997

and physical landscape, and in a sense defines something unique to Wales' engagement with contemporary art.

Stimulating questions face anyone working in this field. One of those questions is by what right and in whose name is 'art for art's sake' placed in the middle of a public landscape, giving people no option but to 'live' with it? The dictatorial behaviour of previous ages; of 'benevolent' patronage; of raising monuments to the 'towering dead', is no longer acceptable and has been largely replaced by artistic considerations. Or so we would like to believe. It may be that it is equally 'dictatorial' to foist high art ideals onto the public. How far can it be a case of 'we know what's good for you'?

The legacy of such decision-making continues. During a drawn-out legal wrangle in the USA the eminent sculptor Richard Serra argued against the removal of his vast sculpture 'Tilted Ark' (1981) from the Federal Plaza in New York, on the grounds that it was a 'site specific' piece, and that its removal therefore meant its destruction. Unlike a freestanding piece of art, it could not be erected anywhere else. He was not successful and the 73 ton curved slab of Corten steel was taken away in 1989. Recognising the significance of this case, the art critic Suzi Gablik wrote that it:

> forces us to consider whether art that is centred on notions of pure freedom and radical autonomy, and subsequently inserted into the public sphere without regard for the relationship it has to other people, to the community, or any consideration except the pursuit of art, can contribute to the common good.[1]

Gablik is critical of art divorced from community and environment and in published work like *The Re-enchantment of Art*, proposes a very different artistic philosophy where art has a regenerative, social role. In fact, the artist may not be involved in the making of permanent artefacts at all; rather than an object it could be an activity, a gesture, a 'service' to the community or to the environment. This concept bears similarities to the idea of 'social sculpture' proposed and pursued by Joseph Beuys, and to the notion of 'the expanded field' of sculpture that Rosalind Krauss identified in art practice from the 1960s[2] onwards.

On the other hand, it is clear that art overly-mediated by consultation, committee, and the demands of the representatives of the 'wider community' can lead to a terrible, compromised mess and that some informed intervention is absolutely essential in the process. It is also clear that many of the charges brought against Serra's sculpture were manufactured by those hostile to the work. It was suggested that the rat population had inexplicably expanded since its installation, or that the 120 ft steel wall constituted a 'terrorist threat' since it could "vent explosive forces not only upwards but also in an angle towards both buildings".

This famous case illustrates the complex arguments that exist and are occasionally magnified by journalists to destabilise a project. In Cywaith Cymru's own experience, the hostility of the local press, through cynical manipulation of information, has led to long-planned schemes being cancelled at short notice. Whether orchestrated or simply mischievous, these campaigns are often based on misunderstanding, misplaced moral outrage, and more, the 'soft target' that contemporary art offers for lazy journalism. These are often all matters of negotiation and balance, and a level of professional experience, advice and management in the field is a vital ingredient in these decision-making processes, and in the dissemination of information. An informed public and an involved client organisation that understands the artist's intentions is far more supportive and will take pride in 'their' artworks, not see them as alien intrusions. Let's not forget that in rural Wales the individuals who live in the landscapes have to negotiate a shift from landscape as means of production to landscape as leisure amenity. More people are working to make the landscape sustainable, not just as

a site for tourist attraction art, but art that is embedded in the community. It was Joseph Beuys again who said that the notion of a people is fundamentally linked to language, that language and soil were ultimately inseparable from the people. Cywaith Cymru has reflected such a belief in its support of the Welsh language, and of the culture of the Cymru Cymraeg, as much as in promoting and enabling indigenous artists to thrive in the visual arts here in Wales.

It was felt that a book dealing with public art in Wales at the moment would have wider value if it dealt with some of these issues from different perspectives, to be not only a selection of case studies, but also a selection of opinions and arguments. This book is therefore not only a celebration of the work of Cywaith Cymru as the national body for public art in Wales over the last two decades, but also attempts to encapsulate some of the experiences of both artists and enablers in this arena.

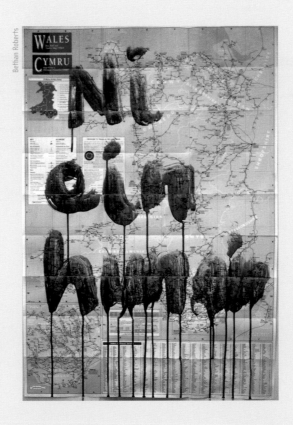

*Ni ein hunain/
we ourselves*
Artefact produced at
one day performance
and installation
'Truth, Lies and
Videotape'
National Eisteddfod
Bro Ogwr 1998

It is through the endeavours of Cywaith Cymru and organisations like it that opportunities in this large and growing area of professional employment have been created for visual artists of all disciplines. The artist, activist and writer Shelagh Hourahane was instrumental in the creation in 1981 of the Welsh Sculpture Trust, later to become Cywaith Cymru . Artworks Wales. In her overview of the past, 'Sites Revisited', she points equally to the problematic areas, the failures, the lack of long-term patronage needed to develop complex and ambitious ideas, as to the successes. She revisits sites of importance both literally and figuratively. Hugh Adams' essay 'Mapping the Field' sets the work of the organisation and public art into a wider historical and social context. He makes the point that, before galleries existed to exhibit 'fine art', art was always seen in the public realm. Galleries for art resulted in art for galleries, separated from the 'public' realm unless the 'public' made a conscious decision to visit these increasingly 'high culture' palaces. The question for some time now has been

how do artists relocate art, and reclaim contemporary practice for the wider 'public realm' outside the gallery? How successful is art as a 'social' tool beyond its ornamental or commemorative function. How does it embed itself into the community?

Once the art is agreed upon, and the artist employed, the work made enters a third phase where it is given over to its environment. It is then at the mercy of the vicissitudes of critic, vandal (not always mutually exclusive), wind and weather, The essay by Peter Lord plainly expresses the disappointment and anguish caused when thoughtless destruction appears to indicate the rejection of a well-intentioned idea. A different form of 'vandalism' is attacked in the fifth essay; that of the sanctioned role of developers and planners. John Gingell has for many years been involved with the debate on the role of art in urban regeneration schemes in Britain and abroad. 'Public Art as Vision, Praxis, Civitas' provides a philosophical reading of our present through our past, and of the role of the artist in the city. His own work amplifies the concept of making art as a form of performance in the public space. Robin Campbell, instrumental in a major redevelopment scheme in Swansea, writes from a first-hand perspective.

The essays by Tamara Krikorian, Director of Cywaith Cymru 1984-2005, Simon Fenoulhet, Deputy Director 1991-2002 and Stephen West, Residencies Manager, present the viewpoint as experienced from within an enabling organisation, and offer not just case studies of individual projects, but of Cywaith Cymru as an organisation with a groundbreaking remit. Stephen West, living in Llangadfan in mid-Wales and travelling widely across country, has been deeply involved with art residencies in communities in the rural areas. Tourism, the growth industry of these areas, has boosted the perception of art 'prettifying' or 'adding interest' to rural as well as urban spaces.

The title of this book was chosen with deliberation. The inference is that the work of Cywaith Cymru has been, and is, groundbreaking. Cywaith Cymru maintains its commitment to formulate opinion and policy as much as to operate as facilitator for the artists. The suggestion implicit in the book title is that much art in the landscape is literally breaking the ground. Whilst a great deal of Cywaith Cymru's commissioned work has done this, there is equally a substantial proportion of work that is ephemeral, or based in community residencies, or incorporated into architecture and the urban environment.

The many illustrations give an idea of this variety of approach. This is art in the changing landscape, human and physical, not art that is simply about the landscape it inhabits.

NOTES

1 'Connected Aesthetics: Art after Individualism' Suzi Gablik in *Mapping the Terrain: new genre public art*. Ed Suzanne Lacy (1995) Seattle Bay Press. p79

2 Rosalind Krauss, 'Sculpture in the Expanded Field', *October*, Cambridge (Mass.) vol. VIII, 1979

3 Joseph Beuys, 'Rede uber das eigene Land', quoted in *The Essential Joseph Beuys*. Thames & Hudson, London 1996

David Hastie
The Gathering (interior view)
Cywaith Cymru artsructure commission,
National Eisteddfod, Meifod 2003

David Mackie
Installation
Neath Abbey 1994

realising
dreams

tamara krikorian

THE ONLY THING THAT'S NEW about public art is the art. Art in public places has always been delivered through patronage of one kind or another, either private (corporate in today's terms) or public via the state or a municipality.

Any changes in public art since the early 1980s have been about changes in art practice; artists pushing boundaries and leading the debate, facilitated by increased public funding in all aspects of our lives including environment, health, education, tourism and the arts. The resources available now for funding art projects in public spaces, through public arts strategies, commissions and residencies as well as artist-led projects, have increased ten-fold in the period from 1980 to the present, fuelled by a plethora of sources of which traditional arts funding is only a small part of the picture.

Expectations have increased on the part of those commissioning as well as the communities they represent. Public Art has become a central force in all aspects of regeneration and restoration in cities – Cardiff, Newport and Swansea – as well as the old industrial areas such as Llanelli, Ebbw Vale and Wrexham.

My role as Director of Cywaith Cymru has been a very personal experience, a job not like any other, a bit like being in a dream. The artist has a licence to dream, to be a visionary, to produce the stuff of other people's dreams, to bring magic into people's lives, to transcend the mundane.

The Ptolemaic Egyptians sought glorification in the afterlife. To this end they employed architects and craftsmen to create a detailed description of their god-like existence and a celebration of their legacy. Flying back from Egypt in 1984, I tried to reconcile the scale of their great temples, the carvings, monumental statuary and magnificent painted friezes, with the world that I was about to enter, commissioning art for public places. The interiors of their temples entered my dreams and have haunted me ever since.

The previous year, I had been invited to Margam Park for the opening of the major outdoor exhibition, organised by the Welsh Sculpture Trust, *Sculpture in a Country Park*. Established in 1981, the Trust had been the inspiration of Shelagh Hourahane, then a lecturer in Visual Arts at University College, Aberystwyth. In 1979, she had co-organised a conference in that town on the subject of sculpture out of doors. This had been well attended and had brought together a number of interested parties, including practising sculptors and architects.

Dylan Wyn Jones
The Blue Cube
GWREIDDIAU/ROOTS
National Eisteddfod
Y Bala 1997

1 5

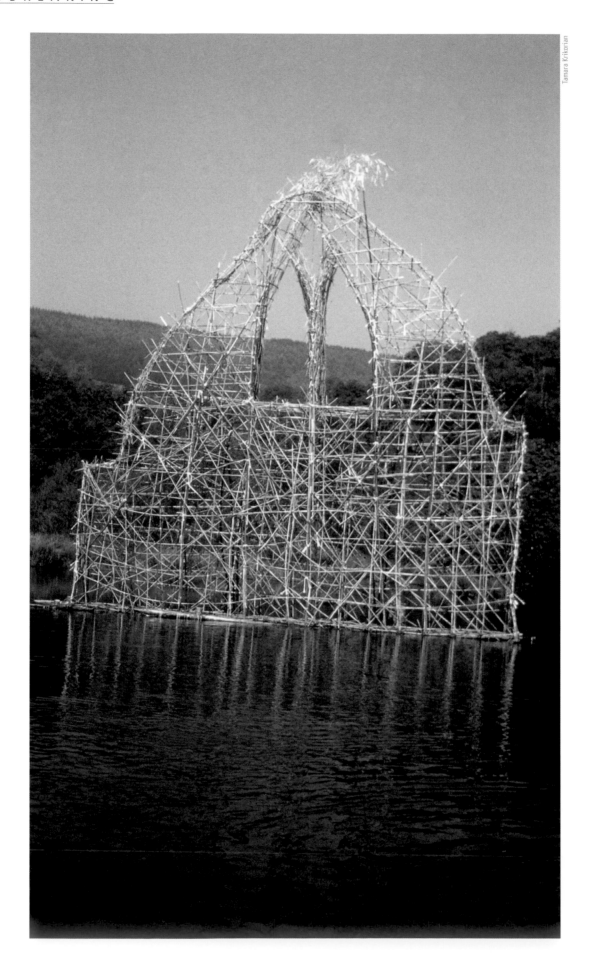

A further meeting was held at Cardiff's City Hall in 1981 bringing together a very wide range of people, including Bruce Griffiths, an eminent QC, who was also Chairman of the Contemporary Art Society for Wales at the time, and Alex Gordon, a distinguished architect with his own practice in Cardiff. At that meeting it was resolved to set up the Welsh Sculpture Trust. It was to be a membership organisation with open membership similar to the National Trust, with activities for members developed on a regional basis. Great emphasis was placed on the need for the Trust to work across the whole of Wales and to draw its ideas from its members and most importantly to act as a catalyst.

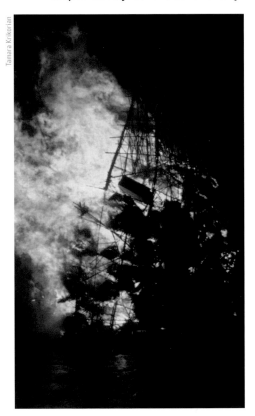

Margam Park, with its exquisite landscape, made the perfect setting for the Trust's first major project. West Glamorgan County Council, owners of the Park, invited the artist Gordon Young, Sculpture Trust Director at the time, to organise an extensive survey of Contemporary British Sculpture.

This was an exhibition of sculpture, an exhibition without walls and a survey of the best. The roll call was impeccable: Henry Moore, Barbara Hepworth, Anthony Caro, Glynn Williams, Peter Randall Page, Richard Deacon, Peter Nicholas, John Maine, David Nash, Jonah Jones and John Gingell. Fifty-five works in all, laid out throughout the Park with the idea that one could explore the grounds at the same time as discovering the sculptures. The work that held most fascination for me on that first visit was one in coal and slate by Avtarjeet Dhanjal, which could only be discovered by walking through a small copse. It seemed to me that the artist had been modest in his approach and highly sensitive to the context.

This was the first large-scale exhibition of sculpture out of doors in Wales. My immediate and adverse reaction was born out of a particular sensitivity to the land from my own background, a childhood spent in west Dorset, with its Bronze Age sites and Saxon churches, where every ditch carries a meaning. My thoughts were fairly cryptic: could the sculptures, most of which had been 'imported', compete against a powerful historic landscape? The backdrop of the sea and the steelworks seemed to overwhelm many of the works, particularly those that had been conceived of as studio works. Could these fragile ideas sustain themselves in the face of nature, the changes in light and weather conditions? Was this not an instance of

Tamara Krikorian

Ian Hunter
Left
Lake Sculpture 1985
Above
Lake Sculpture ablaze
Margam Park 1986

1 7

nature winning over art?

I had overlooked the fact that many people were excited by encountering sculpture of this kind for the first time, sculpture that did not fall into the category of the memorial or the sacred. Many of the people visiting the Park on a regular basis had never been into an art gallery. *Sculpture in a Country Park* left an enduring impression on people's minds. For many years afterwards colleagues would mention the fact that they had seen and been moved by a particular work in the exhibition. The virtue of organising contemporary sculpture exhibitions out of doors, as exemplified at that time by Yorkshire Sculpture Park and the Grizedale Forest project, was that the public could happen upon the work and, perhaps for the first time, begin to think about art, about invention, process and craft.

The Sculpture Trust was resolved not to get drawn into running a permanent Sculpture Park at Margam, having committed themselves from the beginning to act as a catalyst across Wales. The local authority ran a sculpture programme for a few years but was not able to sustain the funding levels needed.

A year later my preconceptions were to be challenged when I took over as Director and found myself at the centre of a critical debate. The debate within the Welsh Sculpture Trust focussed not only on ideas of placing sculpture out of doors, but also on how the work could have meaning for a particular community and how it might reflect the culture of a particular place. The importance of reflecting a particular Welsh identity within projects was central to this discussion. In 1984 the Hywel Dda Memorial Garden at Whitland, a project organised by the Welsh Arts Council's commissions service with Peter Lord as lead artist, had set an example of how the issues related to language and identity could inform a sculpture project.

Exciting initiatives are often dependant on the enthusiasm of one individual. Ioan Bowen Rees, the Chief Executive of Gwynedd County Council in the 1980s and a visionary in terms of issues related to identity, language and self-determination, saw an opportunity to use the Park at Glynllifon near Caernarfon as a place to celebrate Welsh culture in general and the writers of Gwynedd in particular. He had been inspired by seeing an avenue of sculpture celebrating poets in Eastern Europe. As a founder member of the Welsh Sculpture Trust, he felt that the Trust would be best placed to advise on developing such a project.

The Park at Glynllifon had never been open to the public although the Plas, the big house, had been run as an agricultural college for over thirty years. It had been the home of the Newborough family, great patrons of the arts, for centuries. The Park, with the river Llifon running through it, lies in a sheltered valley between the flanks of Snowdonia and the sea and had been laid out in the nineteenth century with fountains, cascades and follies, but had been neglected for a considerable time.

My first visit to Glynllifon with Shelagh Hourahane was another of those occasions that remain fixed in my memory. After lunch in the new County Hall designed by Dewi Prys Thomas, a small group including members of the planning department, Morgan Parry, who was then Manager of the Park,

Peter Lord, Morgen Hall,
and Martin Bellwood
Gwerin y Graith
Parc Glynllifon 1993

Shelagh Hourahane and myself clambered through brambles and long grass to discover the most magical valley in Wales. The park, sealed off behind a great wall, was overgrown and many of the landscape features had been vandalised.

The parallels between Margam and Glynllifon and indeed Middleton, the home of the National Botanic Garden, are striking not only in terms of landscape issues but also because of the move towards retrieving these abandoned great estates of rich landowners for the enjoyment of the community at large. Once again there was a historical landscape, which the County authority, in this case Gwynedd, wished to use to draw tourists to the area. However, the key desire at Glynllifon was to draw the community in from the beginning.

The Writers of Gwynedd project would attempt to reclaim this little paradise, the hidden valley of the Llifon, for the people of the surrounding land, bringing together the separate communities of this essentially Welsh-speaking area. Peter Lord, artist and art historian and Delyth Prys, a literary expert and lexicographer, were invited to prepare a strategy for *The Writers of Gwynedd* project. The plan revolved around twelve sites, which would each reflect a different theme drawn from Welsh literature, creating a series of new landscapes designed by artists. These sites would act as containers for further events, artist-in-residence projects, specially commissioned writing, performances and commissions. A diverse array of artists and designers

including Denys Short, Ian Hunter, Sean Curley, Robert Camlin, Howard Bowcott, Meical Watts, Peter Lord, Morgen Hall, Martin Bellwood and Wil Jones were involved in the initial projects.

There were three defined projects in the first stage: a celebration of the life of O.M. Edwards, who had been a great advocate of children's literature in Wales; drama was represented with particular reference to Saunders Lewis and John Gwilym Jones; and *Gwerin y Graith* (The People of the Scar) a project dedicated to the writing of Kate Roberts and the suffering of the slate quarry workers during the great strike of 1900-03. The site overlooks the slate villages of Penygroes and Rhosgadfan.

The importance of *The Writers of Gwynedd* project and its meaning, most particularly for the people of the area, was reflected in the memorable unveiling of the *Gwerin y Graith* site by George Wright of the Trade and General Workers Union. The TGWU sponsored the *Gwerin y Graith* project, demonstrating its symbolic importance for the nation as a whole.

The elements of the site, designed by Peter Lord in collaboration with other artists including Martin Bellwood, Morgen Hall, Wil Jones and Meical Watts, had a poignancy that will remain in the memory of those most closely involved in the project. Unfortunately the mindless vandalism that destroyed most of the site shook the resolve of the County Council and brought *The Writers of Gwynedd* project to a halt. Since 1990, developments at Glynllifon have been slow, local government re-organisation and re-structuring which continues to blight so many projects in the public sector have, until recently, put the park back to sleep but, as in the story of Sleeping Beauty, a new generation is now seeking to clear away the cobwebs and, with a sensitive approach, attract more visitors to the park.

Many aspects of the project at Glynllifon have acted as a guide to the work of Cywaith Cymru since the 1980s: the notion of collaboration across art forms and different design disciplines within the context of countryside management; the search for cultural resonance; specificity within a particular community. The project sought to explore the layers of cultural meaning that could be drawn out of the park and used to create new forms of cultural expression and celebration. It was a truly groundbreaking project that, had it been fully developed over a ten or fifteen year period, would undoubtedly have gained international recognition for its originality.

What you learn from a project like this is that you need staying power and you need money to fulfil dreams, and you also need time to develop great projects. After all, it took 60 years to build Chartres Cathedral. That is why it is such a struggle to create an enduring arts project at the beginning of the twenty-first century. False economies and impatience do not help the cause of making art.

Cywaith Cymru has sought to explore new forms of artistic expression, while at the same time drawing the community at large into its work. It has also pressed the case for celebrating culture in all its complexity and ensuring that modest aspirations are satisfied as well as the most experimental.

In our work we continue to remember Paul Davies, sculptor,

Mick Petts

Top
Paul Davies
Installation view
Kuopion Taidemuseo,
Finland 1988.
Exchange exhibition
organised by the
Welsh Sculpture Trust

Left and Right
Mick Petts
Mother Earth
Garden Festival of
Wales
Ebbw Vale 1992

performance artist and 'animateur'. He was an inspiration to a generation of artists in Wales as well as true friend and mentor. The story of art in Wales is quite unlike any other. The community is small, spread out geographically but intricately linked like a volatile family. Paul was at the heart of this family. His 'Map of Wales' drawings, paintings and earthworks became legendary. Once, after a Cywaith Cymru Council meeting, he called me out of the office in Cardiff's John Street to look at a pile of recent 'maps', which he had stacked on the floor of his car. Noticing that they were about to take off in the wind, I suggested that he should perhaps take more care of them. But for Paul these were not precious objects; his canvas was a much broader one, and more inclusive. He wanted to enfranchise the less advantaged in society through collaborative projects, which would be stretched by his phenomenal energy and cultural vision. His aim was not to make a commodity of art, but a social action.

The Garden Festival of Wales at Ebbw Vale, in 1992, became the next 'proving' ground for the Sculpture Trust's work, pushing forward the idea that lead artists should be employed as part of the landscape design teams from the inception of a project. Seven artists, including Paul Davies, were invited to work with the landscape teams. Like all Garden Festival projects the programme was tight. Twelve months into the project there was a complete change of personnel and an ensuing change of direction, which meant that some schemes became compromised. Paul Davies however, never traded on ego, his strong work ethic characterised by brute force digging, carrying and shifting large mounds of earth, enabled him to complete his works as planned.

Paul proposed a major land art project for the Festival site 'Land of Our Fathers', which was only partly realised, though other significant works of his exist. At the time of his untimely death in 1994 we were working together on an international

Jan Pohribny

project which was ahead of its time, reflecting as it did on issues of cultural displacement. This project, *Displacement and Change*, involved artists making site-specific work in various locations in and around the University city of Bangor. The original idea had been to involve the invited artists, coming from different cultures, with groups within the local community and to create a dialogue between them. The loss of Paul Davies at a crucial point proved the importance of the local animateur, the person who could bring together the disparate parts of the community in a shared vision.

Displacement and Change sought to reflect the most important questions of our time, cultural displacement and how that might affect the 'displaced' and how the displacement of a person might bring about change in any particular community.

Inviting artists from different cultures to consider this theme and make site-specific work in Bangor was an ambitious idea.

Tamara Krikorian

DISPLACEMENT
AND CHANGE
Bangor 1994

Top Left
Iwan Bala
*Mae'r plant yn gadael
am y dre/The kids are
leaving for the town*

Bottom Left
Sjoerd Buisman
Sigillaria Carbonica

Top Near Right
Una Walker
Installation,
Bangor Cathedral

Top Far Right
*The Battle of the
Novgorodians with
the Suzdalians*
Dmitri Gutov

Bottom Right
Luned Rhys Parri

Jan Pohribny

Martin Roberts

Jan Pohribny

Frazer Henderson

Once again the enthusiastic backing of an individual, the then Vice-Principal of the University, Eric Sunderland, ensured that there was an appreciation of the work within the city. Six artists took part: Dmitri Gutov from Russia; Sjoerd Buisman, Holland; Jan Pohribny, Czech Republic; Una Walker, Ireland; Iwan Bala and Luned Rhys Parri, Wales. While the project had to be modified in terms of the original ambition to involve large sections of the community, it had a significant impact on the town, using locations as diverse as the foreshore of the Menai Straits, the Pier, the Cathedral, a redundant supermarket and an abandoned television studio.

A further exploration of the theme of cultural displacement was undertaken at Bala in 1997 in the project *Gwreiddau* (Roots). This event was planned to coincide with the Bro Meirion National Eisteddfod, held in the town. Five artists originally from the area, Catrin Williams, Iwan Bala, Dylan Wyn Jones, John Meirion Morris and Angharad Pearce Jones, were invited to make site-specific work reflecting the changes that had taken place in that community since they had left to live elsewhere. The artists collaborated with local people, many of whom were family and friends, to provide materials, information and a helping hand. The poignancy of this project was derived from the way it highlighted the dramatic changes that were taking place in rural communities

Martin Roberts

Top Left and Right
GWREIDDIAU/ROOTS
Catrin Williams
National Eisteddfod
Y Bala1997

Bottom Left and Right
Marc Rees
National Eisteddfod
Aberystwyth1992

Frazer Henderson

across Wales. Angharad Pearce Jones' work, with its use of agricultural scrap and coloured plastics, provided a potent symbol for changes in rural life, abandonment and renewal. The rich cultural life of the rural communities around Llyn Tegid – music, art, and literature – echoed many times across Wales, is a vitality that is at risk of ebbing away as people continue to move away to the cities to find work. *Gwreiddau* reflected the struggle of rural communities to survive.

The National Eisteddfod provides a unique platform in terms of celebrating culture, an opportunity to experiment, to present ideas in a raw state and to receive criticism as well as acclaim. Cywaith Cymru has for many years collaborated with artists, poets and musicians, commissioning new works to be made during Eisteddfod week. These collaborations have

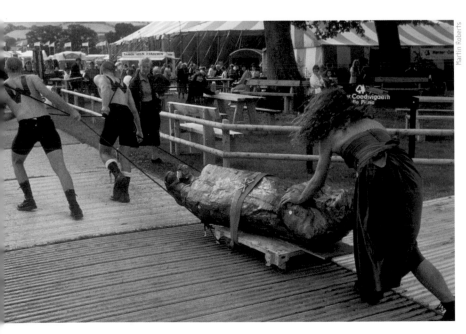

Martin Roberts

Martin Roberts

Top from Left
Peter Finnemore
In the Year 2525
Eisteddfod Llanelli 2000

David Hastie
Y Casgliad/The Gathering
Performance: Myrddin ap Dafydd
and Pep le Pew
Eisteddfod Meifod 2003

Bottom from Left
Bedwyr Williams
Eisteddfod Dinbych 2001
Iwan Llwyd, Osi Rhys Osmond
'Truth, Lies and Videotape'
Eisteddfod Bro Ogwr 1998

Tamara Krikorian

Tamara Krikorian

Tamara Krikorian

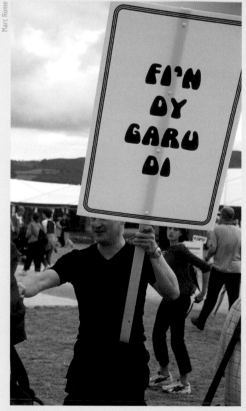

Marc Rome

Iwan Bala

Iwan Bala

Tamara Krikorian

Iwan Bala

Carwyn Evans
Containers
Performance: Sharon Morgan *Ede Hud*
Eisteddfod Casnewydd 2004

Catrin Williams
Bara Brith
Eisteddfod Bro Colwyn 1999

André Stitt
Fi'n dy garu di
Eisteddfod Dinbych 2001

Helen Jones and Sean Curley
Noddfa
Interior and Performance: Gwyneth Glyn
Eisteddfod Eryri 2005

formed an essential part of Cywaith Cymru's core work and have become more visible at this time.

Different themes have emerged each year. At Aberystwyth, Cywaith Cymru invited artists to respond to the unfinished monument of Wellington at Pen Dinas, outside Aberystwyth. Performance artist Marc Rees made an appearance on the Maes in a green velvet dress accompanied by two cohorts, causing considerable surprise. In Bridgend, the poet Iwan Llwyd was invited to join artists Mary Lloyd Jones, Osi Rhys Osmond, Meical Watts and Peter Telfer in an examination of the life of Iolo Morganwg, a man who had much to do with the revival of the Eisteddfod tradition. At the Eisteddfod at Llanelli, Peter Finnemore explored the meaning of the Eisteddfod itself, using a garden shed as a key performance tool. At the Maldwyn Eisteddfod in 2003, David Hastie was commissioned to build a structural artwork that could accommodate performances by poets commissioned by Academi. The success of this experiment led to a similar commission for Carwyn Evans at the Newport Eisteddfod in 2004 and 'Noddfa' (Sanctuary), a collaboration by Helen Jones and Sean Curley at Eisteddfod Eryri in 2005. The singer and poet Gwyneth Glyn performed a new work inspired by the structure. Sharon Morgan's performance within Carwyn Evans' work in 2004 was also highly effective. Other artists who have made a unique contribution to Cywaith Cymru's performance programme at the Eisteddfod include Bedwyr Williams, André Stitt and Terry Chinn.

The National Eisteddfod is one of Europe's greatest secrets, a unique experience, an arena for cultural debate which is of the nation, bringing communities together from across Wales. As an outsider, it is a privilege to feel part of this community. The Eisteddfod is complex and represents many areas of Welsh life, ostensibly through the language but there are many other issues that bind people together in Wales, giving a greater sense of community than one would find perhaps across the border. When I first started with the Welsh Sculpture Trust back in 1981 this was something which eluded me, having lived and worked entirely in the metropolitan environments of London and Edinburgh. My understanding of 'community' was strictly limited. The notion of sharing values across class and age groups was new to me.

By being drawn into close relationships with communities across Wales, I quickly became aware of the wealth of ideas which were on offer and which could be drawn on. As a curator, it was not a question of having the artistic vision and implementing it, as in a gallery, but taking other people's ideas and helping them to turn those ideas into an artistic vision.

The catalytic work of Cywaith Cymru where artists are given the opportunity to experiment, as in the projects already described, or more recently, the *Explorations 2003* exhibition at the National Botanic Garden, offer exemplars, food for thought, ideas for contemplation. The temporary nature of these projects, as with those carried out by artists through the artist-in-residence programme, brings the public into contact with the nub of an idea, which may or may not rest in the mind but could act as a trigger on another occasion.

Images created in a myriad of circumstances, in temporary as well as permanent projects, such as the homage to John Evans at Waunfawr by Meical Watts, the hermit's shed at Beddgelert occupied by Rawley Clay, 'Mother Earth' at Ebbw Vale by Mick Petts, the glass screen at Newport Market by Catrin Jones and the resting place at Tyddyn Môn by Ann Catrin Evans, are a lasting testament to the creative spirit, not only of the artists but also the communities into whose fold the artists are drawn.

The results of collaborations between artists will undoubtedly come as a different experience for each of us. The dog 'Gelert' at Beddgelert and the 'Table of Innocence' at Caerphilly may seem traditional, even prosaic to some, but for others they have a poignancy that goes deep into people's hearts. The binding with a white cloth of a tree in the Carmarthenshire landscape and an installation of shipping containers on the Eisteddfod field may be perplexing, but such projects bring a new and invigorating experience to all who come into contact with the work. It is Cywaith Cymru's role to continue to generate new and equally challenging work which brings magic to people's lives.

Robert Camlin
Table of Innocence
Carved by Ieuan Rees
Caerphilly 1995

Graham Matthews

EXPLORATIONS 2003
National Botanic
Garden of Wales
Llanarthne 2003

Graham Matthews

Left
Richard Harris
*We live between
four walls*

Top Right
Angharad Pearce Jones
Branding the Land

Bottom Right
Buster Simpson
Confluence / Cydlifiad

Graham Matthews

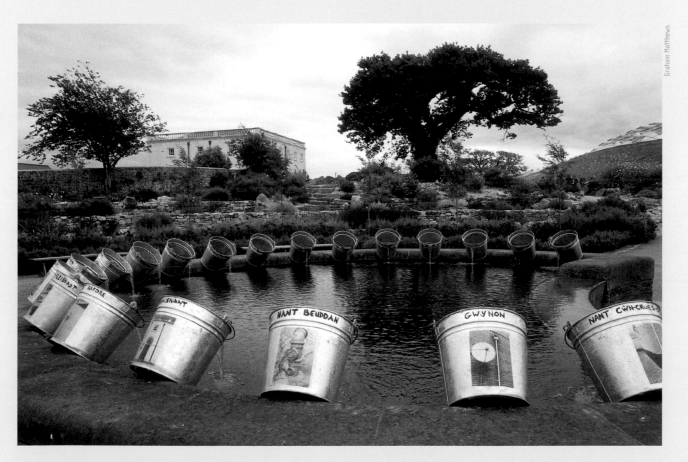

Graham Matthews

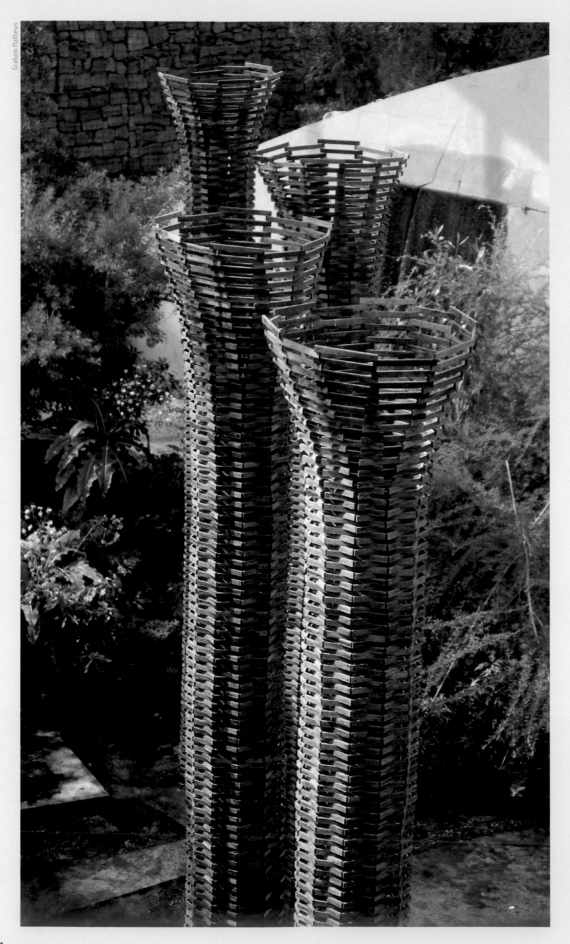

Graham Mathews

Left
Aeneas Wilder
*Untitled,
Installation No. 102*

Right
Susan Dalladay
Dome

Bottom
Craig Wood
Signpost

EXPLORATIONS 2003
National Botanic
Garden of Wales
Llanarthne 2003

Tim Pugh

Graham Mathews

Tim Pugh

Graham Mathews

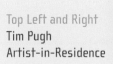

EXPLORATIONS 2003
National Botanic
Garden of Wales
Llanarthne 2003

Left
Philippa Lawrence
Bound
Rare Blooms

Right
Tim Davies
Rosmarinus
Officinalis
Stills from Video

mapping
the field

hugh adams

Mick Petts

THE SIMPLEST OF QUESTIONS are often the hardest to answer and can result in explanations of surprising complexity. In no case is this more so than in considering the matter of Public Art today in Wales, and what its precursors might have been.

So, what is the difference between 'art' and 'Public Art'? Public has a capital letter, pointing to its being something acknowledged as separate and somehow different, from just 'art'. This is problem one! American sculptor and cultural commentator Richard Nonas[1] has said that whenever the word art is qualified by an adjective (such as 'Public', 'Community', 'Outsider', or whatever) it is not in fact art that is indicated but something diminished by the usage, which suggests a lesser activity than art. He thinks there is either art, or no art.

It becomes a problem for us because we are used to the expression 'Public Art' – initially a term employed for bureaucratic convenience rather than as a precise definition of a body of activity. That the art so described was the product of an unprecedented amount of socio-cultural 'engineering' is another, separate problem. This 'engineering' has been going on in the UK for the last thirty or more years, and although claims are made that this 'Public' Art is somehow more accessible than gallery art, it is nonetheless motivated by agendas other than the purely cultural. Such agendas have inherent dangers. Just as it is risky to over-emphasise economic arguments in favour of art (or those based on perceptions of its environmental, regenerative or social value), then so is it to use perceived notions of 'accessibility', to promote its value.

Such nonsenses are legion: as I write people are favouring the jargon-phrase 'socially immersed practice' as synonymous with Public Art. For a time it was the 'Art in Public Places Movement', as if it was some new kind of religion (which, come to think of it, in some ways it was). However, for ease of communication and *pace* Richard Nonas, we have adopted Public Art as shorthand (we all think we know what it means – always convenient when you have lots of people meaning different things) and the usage encompasses activity in crafts, urban design, public decoration, landscape, environmental regeneration and various hybrids. Semantics aside, we have something known as 'Public Art' and generally accepted as 'a Good Thing'.

This acceptance leads to the danger of an orthodoxy being formed, which is precisely the point at which thinking people (and forward-looking organisations) should reappraise the

Mick Petts
Mother Earth
Garden Festival of Wales
Ebbw Vale 1992

whole phenomenon. Happily this book is part of such a process: Cywaith Cymru, the national agency for Public Art in Wales is not merely about to celebrate twenty-five years of activity but also using the anniversary to take stock, doing so in the realisation that no organisation does everything perfectly and that, in a field as volatile as Public Art, there are mistakes, as well as successes to be learned from. There are also new opportunities, fresh contexts to be sought and optimised and new materials to employ. There is now a hugely disparate range of activity encompassed within the field of Public Art. Whilst much of it is very good indeed, some is mediocre and some quite bad. However, just as we have licence to innovate and experiment in pursuit of the enlargement of art and culture in general, so we have a mandate to fail occasionally. Those, like Cywaith Cymru, in the vanguard of practice, will inevitably do so but its corollary is success, which it has enjoyed in abundance. Now, without doubt, it is our duty to learn, continue to take risks and to disseminate our experience.

Public Art is in fact the art that most people see: particularly those people who do not habitually attend art galleries. It is encountered in everyday living. Often the encounter is not realised. This is because the very contexts in which it is experienced serve, on the whole, to integrate it with everyday life, in ways which are not the case for art as it is commonly recognised (isolated in galleries of various kinds). It is infrequently acknowledged just how recent in the history of western art is the convention of its exhibition in galleries. Before galleries became common – say in the early nineteenth century – art was more organically enmeshed with community. Having a strong element of utilitarianism attached, it included an 'organic' concern with the social necessities of commemoration and celebration. Its role in public space was clearly understood, with a widespread comprehension, not just of its function but of its iconography as well. Art as a prominent part of the public realm was unchallenged. Decision makers, autocratic and elected, chose so to place it. Motivations may have varied but all appreciated its purpose and potential.

It is the extent to which Public Art should be 'discrete' which is one of the main problems today, for how may that kind of art, which can happily be seen in a gallery, function in a public space, competing with other environmental factors that clutter the space of contemplation? And how best exposed to an audience, which may well not be versed in art, or sufficiently familiar with its conventions to appreciate what it is seeing?

A related dilemma – the folly of opening an art gallery to all-comers and displaying highly accessible art alongside very experimental and inaccessible art – is increasingly being realised. The idea that a few seconds thought is sufficient to comprehend the latter is a fallacy and one that has contributed hugely to public alienation from art in general. Obviously developing a substantial under-standing of the complexities and nuances of newly-made art is not impossible, but it does require education, time and effort. However, there is much romanticism concerning this. Writing in the RSA journal, Andrea Schleiker suggested that art in galleries is freer from interference by censorship than that in non-gallery public situations. Freer – quite possibly, but knowledge of the recent history of public galleries reveals many cases also of outright censorship; of the abundance of self-censorship in all its subtlety, there is ample evidence. This is emphatically not a plea for imprisoning 'difficult' art in galleries and less controversial stuff outside. We have to acknowledge that siting uncompromis-ingly new art in public places is unlikely to meet either universal comprehension, or acclaim, rather the reverse, though there are surprising exceptions. The 'anything anywhere' approach accounts for many of the mistakes that have been made and accounts also for some of the rather ridiculous stratagems adopted to ingratiate incomprehensible art with an indifferent or alarmed public. That

resulting confusion has provided a long succession of drearily predictable headlines for the philistine media.

It is interesting that, although journalists are generally sufficiently educated to understand (if with a little effort) what good artists and the agencies supporting them, are trying to achieve, they choose to dash for the cliché and write stories of scandal, rather than indulge in real criticism or interpretation. Anyone with the slightest experience of working with public sector bodies engaged in arts development knows what damage results. Public outrage is easily fomented and frequently seeded by lazy, irresponsible journalists in search of a juicy 'art row'. Ironically, their 'angle' often comes from the lack of correspondence between what they see and (what in their reactionary opinion is) 'real art'. Employing the 'waste of public money' chestnut, they consistently dent the credibility of the projects in the mind of the public and make local authorities nervous too. As a consequence an overcautious approach to projects by public agencies, in the UK at any rate, results, when a more experimental one would have been more exciting, productive and culturally compelling.

Sadly, the resulting fear of criticism leads to nervousness. A huge amount of compromised activity has occurred both in anticipation of possible criticism and responding to other than aesthetic agendas. This has resulted in work veering between mediocrity and plain badness. This needs a little qualification, for we must remember that not everyone embarked on 'Public Art' at the same time, or from the same knowledge base. Some individuals, organisations and authorities are still learning, hence still making basic mistakes, that more experienced organisations avoid. There have been intelligent and persistent champions of Public Art, amongst humble advocates, as well as at the highest levels of government. Nowhere more so than in the Health Service, where initial acute difficulties convincing them that money spent on art was not wasteful diversion of clinical funds but good investment, were largely overcome. Today, art's role in accelerating healing and engendering staff well-being is, as a result of a growing corpus of successful projects, empirical research and efficient information diffusion, allowing us to celebrate positive achievement in a wide variety of contexts. Increased knowledge of projects reconciling aesthetically successful work and answering other agendas, renders destructive, ill-informed criticism less likely and less damaging should it happen.

Another impediment to genuine progress in this area is that mediocre cultural bureaucrats have harnessed the Public Art movement in pursuit of other agendas. Some, like social inclusion, are government-determined but there are 'career agendaists' too, many of whom do not understand art but have succeeded in becoming priests in a 'church' and experts in a subculture of non-art art. This is where mantras of 'accountability' and 'accessibility' kick in. 'Social inclusion' another such fad, will, like 'socially-immersed practice', have disappeared from their lexicon well before you read this. A corollary of this and embedded in the very language of the bad cultural administrator, is a form of hideously misapplied political correctness, when to use the wrong buzzword spells career death. Whilst no sane person is against social action via art, these fashions all too frequently exclude good art. The cant word 'elitism' is too often deployed in witch-hunt like situations: an orthodoxy serving only creative stultification. Arts development agencies concerned with Public Art need vigilance to avoid being hijacked by dubiously motivated cynics, to ensure that Public Art achieves not merely low-level consensus but functions brilliantly as authentic art, in contexts conducive to comprehension and true integration with community.

Historically, Wales has had many and varied examples of successful Public Art projects and Cywaith Cymru (as the Welsh Sculpture Trust) was at the fore of developmental work. Shelagh Hourahane tells that particular story here. But

Public Art was not suddenly injected into a void: although deliberate proselytisation for its value occurred, it did so at the end of a 'Public Art' continuum that had already lasted in Wales for well over a thousand years. What we call 'Public Art' now was never called that before and we would feel the absurdity of referring to works such as Leonardo's 'Last Supper', Michelangelo's 'David', or anon's 'Cross of Conbelin' at Margam, as 'Public Art', even though placed in publicly-accessible spaces – city squares, churches, belvederes and gardens – yet that is effectively what they were.

Even extolling art's 'social function' and elevating it above the aesthetic is not doing anything new. Art always possessed such functions: as when, in its use as visual aid in church, it was didactic; politico-social, when used to celebrate achievements of the powerful, or to intimidate the populace in various ways. Many precursors of today's Public Art in Wales not only display similar aesthetic sensibilities, but even appear in latterday versions of its contexts, possessing social, cultural and aesthetic motivations not too dissimilar to their forbears. Overwhelmingly, Public Art's main impetus has been aggrandisement of the individual, of a civic, commercial or religious community and the desire to adorn the fabric of these communities, either as genuine religious devotion or as evidence of wealth and power. We must never discount pleasure and such art as means of sensual stimulation and enjoyment. None of these are purely modern phenomena but as old as human settlements themselves.

It is obvious from examples in this book, that forms of 'social healing', economic and environmental regeneration and so on (what are nowadays termed the 'drivers' of the determination to extend the province of Public Art), are as valid justifications for creativity as self-expression, ornament and celebration. It follows that motivations for having art in public places changed only slightly throughout history. Those improbably great providers of Public Art, Hitler, Stalin and Mussolini, were as convinced of its propagandistic and intimidatory values as they

were of its celebratory ones. Their great temporary public spectacles equate surprisingly with our modern ones: installations, pyrotechnics and environments – the 'total art works' – employed to create surprise and awe, in celebration of the advent of games, or calendar festivals. That their permanent and temporary forms of Public Art have modern equivalents is obvious but we remember too that their models – the 'bread & circuses' of the Romans – also had precursors – in any number of civilisations – back to pre-history.

In terms of its integration with townscape, latter-day Public Art, or much of it, fails to match many earlier achievements and indeed does little but add visual clutter to our environment, both built and natural. The former coherent and harmonious fusion of art, architecture and environment, though still desirable, is something of a rarity nowadays, so it occurs that we should, at least occasionally, rather than add anything to an already crowded context, either insist on a cull, or at least a severe audit, of visual clutter. Signage in particular, much of it absurd and redundant, often excludes any possibility of art. We might though learn much from current advertising, both in its use of new materials and new contexts. It frequently suggests answers to the perennial problem of making suitably scaled impact on a very large space, without unsustainable expense.

Failures in Public Art often stem from lack of adequate research and development time. Securing the best quality art frequently comes well below other public agendas, either because of inadequate planning, or because inventive solutions are rejected for conservative reasons. Maybe too many competing interests interfere with projects, resulting in the blandness of over-compromise. Great art is not usually produced by compromise and rarely, as history shows, by democracy or committee. Too frequently the qualifications of those pronouncing on and affecting Public Art equate with my ability to pronounce on quantum mechanics or brain surgery.

Two areas of Public Art almost invariably result in excellence: one is when it is

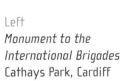

Left
*Monument to the
International Brigades*
Cathays Park, Cardiff

Robert Thomas
Aneurin Bevan
Queens Street, Cardiff

Right
Alfred Gilbert
David Davies
Barry

Iwan Bala

utilitarian in nature and answers (often literally) pedestrian need. We see it in the best fences, signage, walling, patterned pavements, metalwork gates and so on. It is where art is finely textured and attuned to the nuances of place and can be inventive, quietly witty even, but rarely is it strident. Its symbolism tends to be slight in comparison with other forms of art and there is also, as mentioned earlier, a continuing tendency towards commemoration and celebration. The second, contrastingly, is where art is highly symbolic and expresses shared communal values – particularly those of sub-cultural groups and specialised communities. Neither necessitates representational art. Symbolism is often best served by art avoiding realism and literal depiction. Rachel Whiteread's *Holocaust Memorial* in Vienna, Kim Lim's *Vietnam War Memorial* in Washington D.C. and the (anonymous) *Monument to the International Brigades* in Cardiff, are examples. In these we see the reverse of conventional Luytenesque 'Death, August and Royal' style, typical of war memorials. Instead, they are works of epic symbolism, dignity and restraint. The single stone block of the Cardiff memorial looks like a megalith from an Eisteddfod Gorsedd circle and bears an image of a tree, otherwise nothing, save a poem by Dolores Ibárruri – La Pasionaria – and a small explanatory legend. Such minimalist works of art are highly intelligent and extremely moving, models for great non-representational Public Art: appropriately placed, well-embedded in the psyches of their communities.

This prompts us to ask whether 'likeness' matters in public sculpture celebrating an individual or event? Most of our successful examples in Wales are 'realistic' but modern contributions often fail when too literal. How the subject looked in life is surely less important than symbolism suggestive of the person's attributes. This becomes increasingly true, as those who knew the subject personally die. How might a sculpture of Lloyd George express his concupiscence, power, perversity, patriotism, and mischievousness? Take Cardiff's many Bute monuments: what do we look for? Can any individual characteristics emerge from behind the tights and fancy costumes and distinguish one marquis from another? By contrast David Davies' statue, outside his docks offices at Barry, achieves a commemorative ensemble as splendid as many emperors'. It impresses, an expression of individual achievement possibly but the importance is its symbolisation of wealth and power, rather than the physical characteristics of its subject. The unadorned stones commemorating Aneurin Bevan, on his bleak Tredegar mountain top, spur us to greater reflection on his achievements than any plinth-mounted, pedestrian precinct, would-be look-alike ever could. It is difficult for the artist nowadays, when we have no shared symbolic imagery to express virtue, holiness or evil, and have largely lost comprehension of historic symbols as would indicate an individual's attributes. Who knows what Balzac really looked like, who cares? Rodin's image – a whirlwind of a sculpture – will however continue to project his essence down the generations, in a way that no literal depiction could. Public Art needs artists capable of creating compelling symbolic imagery.

Identifying historic precedents for modern Welsh Public Art has an unexpectedly important dimension, one at the root of many current problems which, although not confined to visual art, seem in its case to be most acute. Above all, the process of searching, identifying and recording is an essential part of the recognition of our capacity as a nation to produce art works of enduring value. As I have written elsewhere[2], this ability has frequently been doubted and has resulted in a culture doubting the value of its own products and even its very authenticity as something discrete and indigenous.

These were considerations very much to the fore during the burgeoning of a form of national self-awareness at the end of the nineteenth century – the glad springtime for Wales. Eric Rowan (among the earliest modern chroniclers of the Visual Arts in Wales), in a recent essay[3], points to a number of contemporary,

Elizabeth Ross

Top
Aneurin Bevan
Memorial
Tredegar

Bottom
War Memorial
Cathays Park,
Cardiff

Iwan Bala

seemingly contradictory, stances. He quotes Thomas William Ellis MP, observing in 1898 (after visiting the Paris World Exhibition), that Wales, unlike other countries of similar size, lacked what he called a 'native school'. He believed that a 'national art' would only emerge as a result of what he called enfranchised nationhood. That this has later echoes we shall see, and, given the burgeoning of Welsh visual arts (and the increased stridency of the professional art community's demands) since the advent of the National Assembly, it is very piquant!

During the subsequent hundred years, various commentators celebrated what they viewed as positive in Welsh art but more frequent were lamentations over its perceived inadequacies. In the past, art on either the London, or international art world model, is what seemed most desirable. In the 1930s, novelist Richard Hughes identified the 'problem' as a 'dispersed culture', without a strong dominant focal point (nowadays of course a virtue would be made of that). But well before this, in fact before the nineteenth century was out, serious attempts were being made to remedy perceived 'deficiencies' in art, decorative and fine' by such as the Marquis of Bute. He didn't only criticise what he saw as a lack of great art and architecture but set out to effect change, as when establishing crafts workshops to accompany his epic castle building programme. This had a profound effect on the quality of buildings and crafts in Cardiff and almost coincidentally, its corporation began formulating plans to acquire an appropriate 'cityscape' such as would equip it to plausibly function as a capital. Hence the first year of the twentieth century saw the first foundation stone laid in a hugely ambitious scheme, resulting in Cardiff's possession of one of the finest ensembles of public buildings in Europe. Its corollary was commissioning, on a scale to outrival even the marquis, of sculpture, painting and decorative arts. Cardiff, one of the wealthiest towns in the world then, acquired the accoutrements of a city (and became one, in 1905); its chosen style was a highly original eclectic; with the correct blend of curiosity, pomposity and civic gravitas, it succeeds on every level. It is true its embellishment contains no greatly original individual works of art, yet the whole is impressive with decorative art central. Exuding massive self-confidence it palpably marked the beginning of the journey to enfranchised nationhood, eloquently testifying to how appropriate art can contribute to self-confidence, feelings of social wellbeing and project this confidence to potential investors in a community, which are all excellent arguments in favour of art in public places today!

These developments alone serve to demonstrate how the history of the visual arts in Wales has been consistently marginalised and absented from the British art historical narrative, either through critical neglect, or downgrading, literally written down. Responsibility lies principally with English commentators and Welsh ones striving for anglicisation and distance from their native culture. Any attempts at redress ought to be viewed not as chauvinism, or silly nationalism but an objective attempt at fairness and historical accuracy. A result of the recent and accelerating, research, discovery and recovery, should be the rapid importation of Welsh things of visual cultural significance into its curriculum, at all levels. Any culture or education minister worth their salt would be vigorous in remedying this 'cultural wound'. Knowledge that Wales has produced unrecorded and unpublished things of great worth in art is growing, just as dismissive attitudes towards it are eroding but such historic facts will never be universally recognised or indelibly established, unless they form part of our curriculum. The long lone voice of Eric Rowan has company now: Peter Lord's, whose superb and authoritative series of books *The Visual Culture of Wales*[4] ought to be in every school, university and public library. John Newman's *Pevsners: The Buildings of Wales*[5] similarly. Both series are epic in scale and achievement, bringing us the fruits of forensic art historical skills and allowing us to know things about our art

and built environment, about which previously we could only speculate. Another epic task has been Angela Gaffney's, whose recording of Welsh public monuments and sculpture has been exhaustive, to which her visual database (at the National Museum and Gallery of Wales, Cardiff) testifies. The number of high quality books and catalogues about Wales' visual arts in general, also increases rapidly. Another and dramatic instance of this knowledge explosion about our own cultural history, is the wealth of recovery activity in distinguished ornamental gardens and landscapes, some of seminal importance, throughout Wales. Many had become anonymous, through ignorance and resultant neglect and abandonment. Now we realise they are not only art in themselves but increasingly are serving as vehicles for the display of our finest art and crafts.

I feel there to be two distinct phases into which Public Art falls. For convenience I call these the 'organic' and the 'engineered'. The organic is historical art activity occurring in places construed as public, 'un-selfconsciously' and before public cultural bodies started their advocacy. The engineered is a fairly recent development and, although not precisely dateable, it had certainly begun in Wales by the mid-Seventies. As with much else in the development of a modern Welsh visual culture, it began largely as a result of the activity of the (then) Welsh Arts Council and particularly that of its energetic and visionary Director of Art, Peter Jones. He has been described as a

> ...tremendous advocate for Wales and Welsh Art internationally and around the table at the Arts Council (of Great Britain) in Piccadilly, where he was admired for the ground-breaking work he had done – that series of exhibitions Art & Society, the billboards on the roadsides up in the valleys for example... there was a heady mix of skills and experiences, which created a special dynamic and freedom to work with artists and art and involve the public in that process.[6]

That represented the beginning of a 'great period' for Welsh visual arts, when the foundations of much of what we presently value was laid. This deliberate cultural 'seeding process' saw the encouragement of discourse about art via the annual Gregynog conferences (e.g. *Art Duties and Freedoms; Artists & Politics; Art in A Small Nation; Creativity & Self-Deception*), of which there were some nine in all. Small contemporary art spaces – the present Oriel network – were established. The Association of Artists and Designers in Wales was encouraged. Exhibition of art and the enlargement of its audience were cleverly enhanced through the series of Art & Society exhibitions and art examined in tandem with other disciplines (*Art & War, Art & Worship, Art & Sex, The Art of the Engineer*).[7] A Commissioning Officer was appointed, having a brief to develop art in public places in Wales (although the initial motivation was to ensure the employment and remuneration of artists). Knock-on effects were significant: Wales, its Arts Council particularly, was very much in the vanguard as far as the recognition of the connection between artists, their employment and the audience was concerned. Grant-aid was recognised as insufficient in itself, in the absence of a visual arts infrastructure and economy and things like the series of master classes and apprenticeships were introduced, as early forms of present 'professional development'. So was Collectorplan, another Welsh first – now much emulated – which encouraged the public to buy contemporary art and craft via interest-free loans. In general there was a preparedness to take risks which no other similar body in the UK was willing to take and introduce innovations of a kind that took considerable time to become universally accepted.

Other coincident initiatives had similarly profound effects. The Peter Stuyvesant Foundation's City Sculpture Project, directed by the late Jeremy Rees, was significant in placing modern sculpture outdoors. It might though be held to have put back the cause of Public Art: vanguardist sculptures were sited in major British

towns. In Cardiff one in the Castle moat and another in the Hayes, were, like works in other cities, intended to stay for six months, then offered for sale but both were vandalised. These examples of what later came to be called 'parachute art' (i.e. that introduced without any natural social or cultural context, without a previous educational programme, or consultation), caused only resentment and yet it was probably a necessary risk to take, as lessons were certainly learned.

Another outstanding but still not yet fully recorded, development was the Barry Summer School. Under the visionary leadership of inspired artist-educationalist Leslie Moore and creative bureaucrat Wyndham Haycock, an unremarkable, annual accreditation course for evening institute instructors, metamorphosed into a Welsh Bauhaus. From the late 1950s, many of the most significant practitioners and theoreticians from the international art world congregated at Barry indulging in interdisciplinary practice of the most advanced kind. Barry residents experienced the furthest shores of performance art and Fluxus events before most in Britain. A further result was the appointment of educational radical Tom Hudson as head of Cardiff Art School, where he introduced an experimental curriculum, subsequently emulated worldwide. His recruitment of artist-teachers sympathetic to his ideas was hugely catalytic in the country's visual cultural life – in a way almost unimaginable in most of the business ethos, bureaucracy-laden art schools of today.

The prevalent spirit of official encouragement and the enthusiasm of enlightened individuals resulted in many significant developments, of which the establishment of the Welsh Sculpture Trust, the brainchild of artist and writer Shelagh Hourahane, was one. Initially not devoted to the development of Public Art, sculpture alone was its focus. An early initiative was the establishment of a programme of sculpture in the grounds of Margam Castle. The choice of site was particularly imaginative. It had, for sculpture in particular, huge cultural resonance, in that its history as a site for superlative art extended well over a thousand years. Interestingly, Public Art had, in those countries where it was most advanced, begun in sculpture parks but eventually the spirit of the times moved against them and they came to be spoken of as 'sculpture zoos'. It became clear that the future for sculpture, rather than its isolation in specialist parks lay in greater integration of art with the overall environmental fabric.

This early seeding work had other unforeseen effects: the Cardiff Bay Arts Trust was established at just the point when Public Art became almost universally employed in processes of urban regeneration, economic and cultural renewal. The result was that Wales had major official commitments to art in public places: Newport is a prime example and very early on, developed a fine ensemble of Public Art as catalyst in its regeneration programmes. Later came the harbour-side developments at Swansea and Cardiff Bay, both highly regarded as a model for the widest applications of art, crafts and design in environmental renewal. All demonstrated substantial evidence of emancipation from the plinth-borne, academic memorial sculpture which had predominated the Public Art of the previous few centuries.

But pre-empting civic art developments were those in ecclesiastical art, which might be thought to have been an unpropitious sphere for excellence in non-conformist puritan Wales. Intrinsically 'public', this has a particularly interesting pedigree in the Church in Wales, which has been an international leader. An apogee was reached in the 'Llandaff Commissions'. The cathedral, wrecked by a bomb in 1941, was the crucible and the coincidence of Glyn Simon a visionary bishop and Eryl Thomas, an equally inspired Dean, led to George Pace's appointment in 1949 as architect and surveyor of the fabric. He had done extensive reconstruction and building work elsewhere, but Llandaff was his magnum opus. He was totally committed to the fusion of art, architecture, music and the

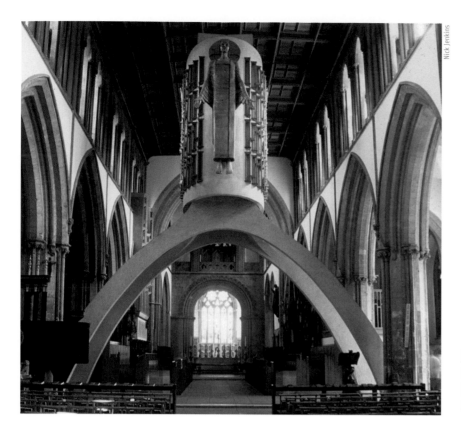

Jacob Epstein / George Pace
Christ in Majesty
Llandaff Cathedral
Cardiff 1954

dance of language and movement in liturgy, an alliance of all the arts into a harmonious whole. His attention to detail was total, in building and every element of fittings, furniture, vestments and robes. His genius lay in the combination of work in uncompromising modern idiom with the best of the old. Hence his breathtakingly daring marriage of modern concrete with residual Pre-Raphaelite sculptures, in his double parabolic arched 'choir screen'. An even more daring move was commissioning Sir Jacob Epstein's *Llandaff Majestas (Christ in Majesty)* and obloquy unprecedented was endured by architect and church authorities as a result of that daring. Criticised not simply on aesthetic grounds but for employing a Jew to produce an artwork for a Christian building, bravely they stood their ground, so that the cathedral now has one of the oldest, most successful and consistently maintained, programmes for the commissioning of art in worship anywhere.[8]

In the light of the vigour and self-confidence evident in Wales' visual arts scene today and in the light of palpable achievements in art already evident at the time it was written, it is difficult to believe that the following represented attitudes long and widely-held:

> The trouble is that other nations have a visible culture, and we can enjoy their painting, sculpture and architecture with little difficulty, while the Welsh have, uniquely, no visual arts at all, being confined to singing, brass bands and poetry which, however magnificent it may be, is in a language which one has no other inducement to learn...[9]

By 1974, when this was last published, many of the initiatives mentioned above had already been in train for some time and of course Wales' artists had and in reasonable numbers, appeared successfully on the international stage, for over two hundred years. Yet in the art history texts they feature either not at all, or as English artists. Fortunately, the woeful ignorance and bigoted claptrap the statement betrays is disappearing fast. This is due, not only to the the writers I

have mentioned but the very incidence and cumulative effects of – increasingly self-confident – Welsh artists, who are indulging in exhibitions, discourse and project work the world over and earning the acclaim of their international peers. The need for adroit cultural engineering seems though to continue (as the financial resources we feel it necessary to devote to Wales at the Venice Biennale and the Artes Mundi Prize demonstrate). Certainly there is still need to combat the powerful, yet substantially uninformed, hegemony of the London art world and its idiocies.

Such things demonstrate the urgency for a comprehensive history of visual arts in Wales since the middle of last century to be written. When it is, it will be necessary to include the pivotal role Public Art has played in consciousness-raising. This is acknowledged, but the incidence of such art in our society does not simply need to increase but needs constant refining and discourse aimed at improvement in quality and relevance. It is not mere elitism to ensure that we have work of the highest quality. We constantly need to redefine what we mean by Public Art and ensure that it abandons the trivial and easy to form a substantial enduring part of the Public Art continuum. The demand for objective critical scrutiny, which has grown in force, will contribute to this. But we must be firm in asserting that what is regarded as good, relevant and valuable should first be of the highest quality and determined, not according to institutionalised international art-world criteria but locally. Our communities deserve the best art, not the easiest to understand on a superficial level. A visual studies curriculum, with a strong and accurate Welsh dimension, in which a true account of history enmeshes with a knowledge and critical approach to current practice, is the way to achieve this. Cywaith Cymru sees its responsibility, not only in maintaining high quality practice but also in increasing an appreciation of worth and valuing the potential for artists to enrich our culture and our understanding of ourselves.

Notes

1 Richard Nonas Artist 'The Snake in the Garden' from ed Michael D. Hall et al *Outsider: Creativity and the Boundaries of Culture* Smithsonian, Washington 1994

2 Hugh Adams *Imaging Wales – contemporary art in context* Seren, Bridgend 2003

3 Eric Rowan (catalogue essay) in O. Fairclough, R. Hozee & C. Verdickt (eds.) *Art in Exile: Flanders, Wales and the First World War* Pandora & the National Museums & Galleries of Wales 2002

4 Peter Lord *The Visual Culture of Wales* (three volumes) University of Wales Press, Cardiff: 1 *Industrial Society*, 1998; 2 *Imaging the Nation*, 2000; 3 *Medieval Vision* 2003

5 John Newman *Pevsners: The Buildings of Wales* (six volumes) e.g.*Glamorgan* (1995) Penguin Books/University of Wales Press

6 Informally published (University of Wales Aberystwyth & the Welsh Arts Council), various dates in the 70s, this series is of seminal importance and still substantially relevant (some titles – *The Judgement of Art* and *Art – Duties and Freedoms* still appear on booklists for Arts Management Courses, as at Sussex University)

7 Ken Baynes et al. the *Art & Society* series was published by the Arts Council of Great Britain and Lund Humphries e.g. *Art & Society: Sex*, London 1972

8 see P. Pace *The Architecture of George Pace*, Batsford London 1990

9 Barbara Jones *Follies and Grottoes*, Constable London 1974

sites revisited
– artwork in
our public
places

shelagh hourahane

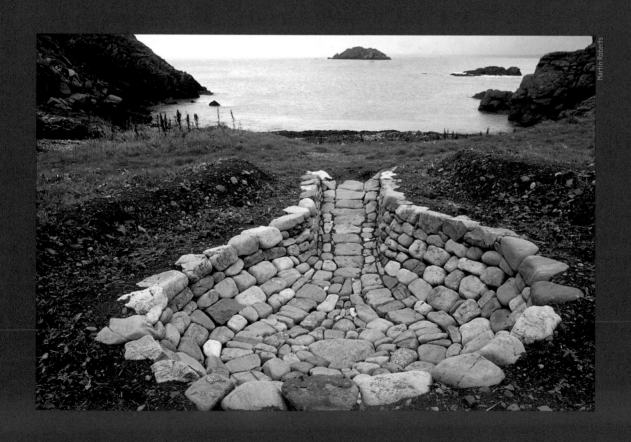

Alain Ayers
The Eyes of the Sea
Millhaven,
Pembrokeshire 1990

ONE LAST GLANCE and there is Cardiff for you, or at least the clutter of Central Square, where the real space is confined to the narrow band of dismal paving in front of the Railway Station on which Bill Pye's sculpture sits. I'm about to be squeezed through the automatic doors that will shunt me into the world of trains and the journey back to northern Wales, but I have time to feel sad that this piece of art is so compromised by its surroundings and by the circumstances that conspired to turn a good idea into what looks like a miserable afterthought. The artist wanted to conjure the presence of Cader Idris, our most beautiful of mountains, serenely sprawling its fabulous curves across the very part of the land to which I am about to return. To me the sculpture fails to even suggest the shape of the mountain and hints at a dilemma in attempting to substitute symbolic form for something as specific as a famous landscape. However, the real problems lie with the much-vaunted redesign of this public space and the fact that the city planners failed to carry through their vision of a sweep of welcome space that took one through from Cardiff Central to the Millennium Stadium. Within this better vision a piece of sculpture could have been allowed to breathe within its own space. Instead, the concessions began when the various stakeholders in Central Square, public and private interests, began to assert their clamouring claims and pushed the wider vision under the table of dissent. The sculpture proposal struggled on, well funded but not well founded, committed to placing a well-known artist's work in a meagre public space. The story that I am about to unfold starts therefore, with the difficulties which sometimes beset the commissioning of public sculpture as it becomes entangled in the rules and rivalries of the world of public utilities and various government organisations.

The train pulls slowly out of Cardiff, though few of us are ready to settle at our windows and so most miss the glimpse of John Gingell's huge and colourful sculpture that prances across the roof of an electricity power substation nearby. This sculpture surprises and pleases me every time I see it, usually on the way into Cardiff Central, but this time I contrast its show of dynamic energy with the earth-bound Cader Idris humped outside the station. A while later, as the train sidles through Newport, another monumental statement about modern technology and the recent past of the steel industry briefly holds the frame in the form of Peter Fink's 'Steel Wave', a daring design completed at great expense in 1990. I mentally make a contrast between it

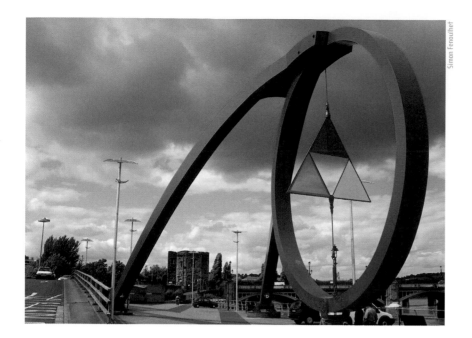

Simon Fenouthet

and the figurative, stone-carved memorial to Newport's Merchant Seamen by Sebastien Boyesen begun in 1990, reminding myself that, with Swansea, Newport took the lead, back in the 1980s, when Welsh local authorities started to take an interest in art in their public places and inserted a strategy for public art into their plans for creating a new urban environment. So often it is one person who provides the force behind such a dynamic, the champion, as he or she would have been called in the past. In the case of Newport this lead was taken by energetic Sir Harry Jones, the Leader of the Council. He was a mover in the campaign to ensure that Newport would start the twenty-first century not as a town, but as a city, a campaign in which public art must seem to have had a part to play. But has all this made a difference to the people of Newport and the eastern Valleys? There is certainly a tradition now in that part of Wales that assumes that artists have a contribution to make to urban regeneration and that is evidenced by its inclusion in the recent designs for making public space in Caerphilly and its surrounding villages. It isn't easy to measure the effectiveness of public art, but it certainly answers an age-old need to embellish public spaces with images, which speak of the past and present. As Mark Howland from Caerphilly County Borough Council commented, an urban space may incorporate "...symbols of the past, but the impetus for the scheme is the future".

My train soon leaves Wales and rattles along the tracks of the English borderlands, giving me plenty of time to muse on these things and to journey back in my mind over the last quarter of a century to revisit the varied places where we have sited art works, bringing them out of the seclusion of gallery spaces and into full public view. The 1970s and 1980s were an exciting time for those of us hooked onto sculpture and the outdoors. Then it was all about sculpture parks and what these outdoor spaces had to offer which their indoor counterparts could not. The first hints of what

Left
Peter Fink
Steel Wave
Newport 1990

Right
Sebastien Boyesen
Merchant Navy
Memorial
Newport 1991

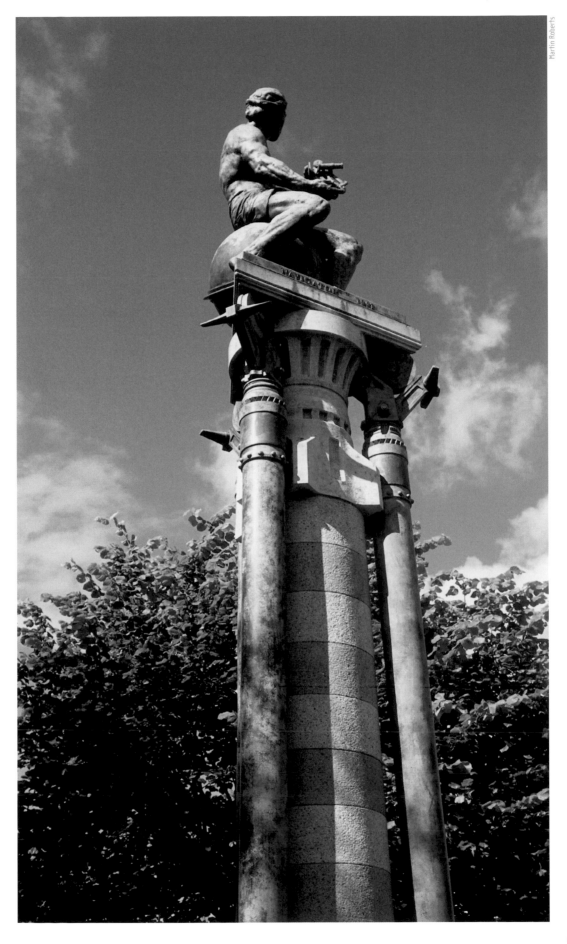

could be came when temporary and semi-permanent exhibitions began to be held in urban park settings. The sculpture exhibitions held in Battersea Park in the 1970s heralded more such exhibitions and facilitated the transition from European traditions of park design incorporating sculptural monuments and decorative features to the idea of a permanent sculpture park within a public space. I read about the European sculpture parks, with their extensive collections of twentieth century sculpture and so began my journeying, taking off by car to seek out first the Kroller-Muller Sculpture Park in the middle of a forest park in Holland and then the more formal Middleheim Park in Belgium. But exciting experiments in creating special sites for showing outdoor sculpture were already happening in Britain and 1979 also took me to see the Yorkshire Sculpture Park, recently started in the grounds of Bretton Hall College. This proved to be a useful model of co-operation between a local authority, a regional arts association and the college itself. Elsewhere, the attitude of countryside agencies, such as the Forestry Commission, towards public access and interpretation was also about to undergo a significant change, one which stimulated a symbiotic relationship between artists and the natural environment, already foreshadowed by the ground breaking Grizedale Forest project (started in 1977), when Richard Harris was commissioned as the first sculptor in residence. This large forest in Cumbria was gradually infiltrated by sculptors such as David Nash, David Kemp and Kier Smith, working with the materials found in the woodland and taking on the concept of minimal intervention in the environment. When I visited in 1979 Richard Harris showed me the work that he was currently making there and, as I walked around the forest trails, I became determined that we should have something like this in Wales.

The birth of deeply rural settings for sculpture displays, such

Richard Harris

Left
Richard Harris
Quarry Structure,
Grizedale Forest 1978

Right Top
SCULPTURE AT
MARGAM 1983
Glynn Williams
The Shout
Bottom
Richard Deacon

as Grizedale Forest, had much to do with the upsurge of freedom for most of the population to drive into the country-side due to car ownership increasing and also with a growing awareness of the tourism value of the landscape. The establishment of country parks during the 1970s provided another significant link between the politics of landscape use and the growth of outdoor sculpture exhibitions and projects. While these factors are of great importance to an understanding of this history, the approximately simultaneous development of new aesthetic concerns also played their part. By the end of the 1960s avant garde art, boosted by the politics of protest and anti the establishment, sought ways to side-step dealer control through galleries. Alongside this, enthusiasm for a new kind of *arte povera* helped to reinstate found and natural materials while simultaneously artists began to formulate an environmentalist ideology.

The Welsh Sculpture Trust came into being during this, the heyday of country parks, of sculpture parks and of open-air exhibitions, just as Wales was also clambering aboard the charabanc about to trip into the bracing future of countryside recreation. Hot foot from my travels outside Wales I helped to organise a day conference in Aberystwyth in April 1980. There was an air of enthusiasm and lots of suggestions, such as a Wales-long sculpture trail taking the North-South route of the A470 and aiming to punctuate the long drive with striking visual statements. It never happened as, after the inaugural meeting in November 1981, the Welsh Sculpture Trust (WST) focused its early activities on temporary exhibitions at Margam Country Park, encouraged by the interest of West Glamorgan County Council which owned the venue. The vision was there though and we were really determined that art in public places could make a difference in Wales. A leaflet produced in 1981 to publicise the new Trust stated:

> A Nation's Culture is expressed in its visual arts as it is in its music and its literature. Sculpture should not be confined to museums and memorials. It should enrich the environment of the people of Wales, on buildings and in open spaces. It should be enjoyed by the public in Sculpture Parks, where exhibitions of the best Welsh, British, and European sculpture can promote a wider appreciation and understanding of this art.

The Inaugural Exhibition held in the summer of 1983 and strenuously managed by Gordon Young, the Trust's first Director, put Wales on the map of outdoor sculptural activity. Suddenly, we were in international directories of sculpture parks and invited to conferences to discuss the future of sculpture liberated from gallery spaces. This type of activity has continued with occasional exhibitions, carefully curated to suit a particular environment. In the grounds of Powis Castle near Welshpool, *Stoneworks* (1988) was an extremely satisfying project (a collaboration with Oriel 31, Newtown) , focusing on a historic tradition and daring to place contemporary stone carvings in the prestigious gardens owned by the National Trust. Almost a decade later *Sculpture in the Park* (1997) at the Festival Park,

Martin Roberts

Martin Roberts

Ebbw Vale, brought the old steel works site to life with a sudden rash of challenging sculptures, such as David Jones' 'More than Six Items', made from a line of supermarket shopping trolleys. All these sculpture exhibitions took place in venues visited by large numbers of people, most of whom would never have looked at art and certainly would not have considered entering an art gallery. Some came for particular reasons, such as the scores of steelworkers who came to Margam Park to see an exhibition by Roy Kitchen and to learn how an artist could transform their material through his imagination and skill. I spent a lot of time at Margam in the 1980s and must have encountered a generation of local schoolchildren growing from adolescents into adults having some experience of the world of art.

Left
STONEWORKS
Powis Castle
Welshpool 1988

Kim Lim
Naga

Vincent Woropay
Patagon (Big Foot)

Right
SCULPTURE IN THE PARK
Ebbw Vale 1997

Richard Harris
Through the Air

It is possible to criticise sculpture parks and outdoor exhibitions as merely having transferred the gallery situation outside. There was some truth in this as an artist such as Anthony Caro, for whom form was his paramount consideration, insisted on placing outdoor work in a defined space so that it was not impinged upon by the vagaries of the natural forms around it. However the concern with placing sculpture in other types of public spaces had also been developing and the very first exhibition arranged by the Welsh Sculpture Trust, *Maquettes for Public Sculpture* held in 1982 in the Orangery at Margam Park had signalled this interest. I put together this exhibition of models made by artists for large-scale commissions and I was surprised at the extent to which it demonstrated that the placing of contemporary artwork in public places already had a history in Wales.

Harvey Hood's sculpture for the railway station at Newport was a significant monument for its time, as it clearly referred to railway engineering while avoiding figurative detail.

Maquettes for Public Sculpture presented fairly conventional approaches to making public art, whereas the 1980s were to be a period of experiment and intervention, in which public sculpture in Wales was seen to be capable of developing entirely new approaches to interpretation and the design of public space. It also began to tackle the issue of a cultural heritage that was specific to Wales. *Cofeb Hywel Dda* at Whitland (1984), managed by the commissions office of the Arts Council of Wales, was a forerunner

of these concerns. It also pioneered the co-working of an artist-designer, Peter Lord and an architect, David Thomas. The design of this garden and visitor centre, set in the space left by the removal of the cattle market, was to become an essay in visual narrative and attempted to conjure the court of the tenth century ruler into the heart of its plain, unadorned and unembellished twentieth-century descendent. The gem richness of enamels inset into slate, the complex floor mosaics and the archaic inscribed texts re-created an aristocratic environment that defied the modern urban drabness, harking back to the intricacy of Hywel's Laws and of court poetry.

I haven't returned to Whitland for years and I know that the full worth of the project was squandered because of a lack of real commitment by local people and by public organisations, resulting in its failure to become the interpretive tool that was intended. Over the intervening years we have learnt a lot about the value of the right kind of consultative process and the hindrance that comes from

the wrong kind, although it is never easy to get it right. How does one trim the hedge of preconception and prejudice, which surrounds so many commissioning situations, in order to allow the artist to exercise originality while also responding to a brief? Perhaps in the case of *Cofeb Hywel Dda*, the whole conception was also ahead of its time in posing questions of identity through public art. A few years after this the Welsh Sculpture Trust embarked on a grand and now almost forgotten project of its own, *Celebration of the Writers of Gwynedd* at Parc Glynllifon near Caernarfon. An opportunity to put Wales ahead of the game in seminal interpretive public art was presented by Gwynedd County Council, at that time led by the cultured and enthusiastic Ioan Bowen Rees as Chief Executive. I walked again along the browned and leaf-spotted paths of Parc Glynllifon on a late November day and there was no one else around as I revisited the place where I had spent many days over several years as the *Writers of Gwynedd* was planned and gradually took shape. That shape was first formed by Peter Lord and Delyth Prys in a project study that saw the Park transformed by its visual celebration of the long and varied literary culture of Gwynedd. It was to be a fine tool for learning and for remembrance. Mixed feelings stalked my solitary Saturday walk and questions raced beside me. I mused that placing art in public places is all about taking risks. If the work takes too permanent a form it stands to be misunderstood, disfavoured or plain forgotten when the people who wanted to make a statement, to share a vision or a memory, are themselves dispossessed and superseded. Our restless time always wants to move on, to the new project, to have the quick return on its investment of public or private money. It would have taken twenty years at least to complete the ten or more land sculptures that were to have celebrated the writers of Gwynedd.

Martin Roberts

There is no public patronage which has sufficient longevity of purpose to create genuine modern monuments.

Children's Literature, completed in 1990 to the designs of an inventive team, including Stuart Griffiths, Robert Camlin and Denys Short, has matured to be a place of mossy mystery. I again felt my way into its dark, passaged mound to reach the domed space inside, where children had buried a few toys as tokens. I stood inside the magical circle of slate monoliths, silent with the memories of stories told within its embrace. Paths through the Country Park took me past familiar follies, left there by the Newborough family centuries ago, to find again the place chosen by Peter Lord for *Gwerin y Graith* (the People of the Scar) to assert the claims of the working people who lived and wrote in the quarrying villages beyond the boundaries of the gentry estate. Now, sadly bereft of its crafted details, the sculptural ensemble still speaks of the poverty, the loss and the scarring of the people in those communities, paralleling the powerful literature of Kate Roberts, T. Rowland Hughes and Caradog Pritchard. The pillar topped by broken shards of domestic pots is sufficient to eloquently speak its message of broken lives. Leaving this sculpture of sad defiance, I scurry past

the unfinished amphitheatre where 'Drama' should have held its sway and contemplate this whole project as being a grand vision and a project that was considered to be seminal at the time, yet which sadly proved impossible to fulfil because of changes in the priorities of Gwynedd County Council.

The Celebration of the Writers of Gwynedd was a triumph in that it demonstrated the stated aim of the Welsh Sculpture Trust to act as a catalyst to cultural developments in Wales. For twenty years the Trust has worked to validate this claim and to maintain this purpose in a world in which it is difficult to originate ambitious and thought-provoking schemes. During the 1990s a strategy of initiating occasional, temporary interventions demonstrated that the organisation, now known as Cywaith Cymru . Artworks Wales, continued its commitment to the issues of culture and identity. *Displacement and Change*, an event held in 1994 in various temporary locations around Bangor, was an experiment in inviting Welsh artists to mix with visiting artists from other European countries. The challenge was to express the various experiences of political, social and cultural displacements across Europe. The project worked well as an international symposium of artists but it needed more funds and possibly extensive interaction with immigrant groups in Wales to succeed in its aims. Since the early 1990s a much greater focus on the issue of cultural diversity has developed within Wales and it might be interesting to suggest a re-run of *Displacement and Change* in a twenty-first-century context.

Since 1992 there have been regular events associated with the National Eisteddfod, which gave individual artists opportunities to express their sense of place and to tap the spring of cultural themes. *Roots* at Bala in 1997 was especially impressive as it gave six artists, who had personal connections with the area, the opportunity to make work in paint, collage, sculpture and installation, expressing something of the links between 'y bro Cymraeg' and the ideas of contemporary artists. Iwan Bala worked with schoolchildren to make his painting 'Cof Bro Mebyd', which included images of the things that they valued in

Left
Denys Short
Maen Hir
Tribute to O.M. Edwards
Children's Literature Site
Plas Glynllifon 1990

Right
GWREIDDIAU/ROOTS
Angharad Pearce Jones
Hadau/Seeds
National Eisteddfod,
Y Bala 1997

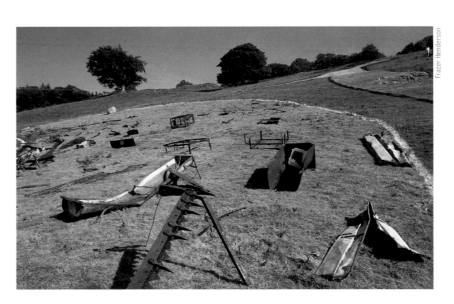

Frazer Henderson

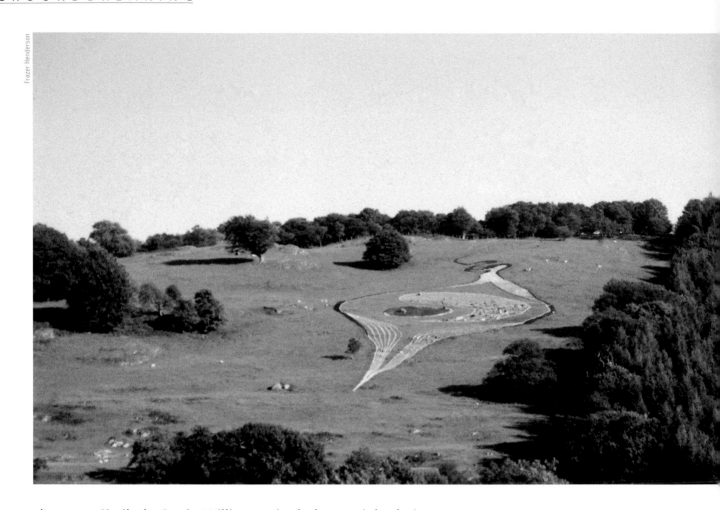

Frazer Henderson

the area. Similarly Catrin Williams mingled material relating to her own childhood with that produced by young people in Bala today in the banners and installation that was called 'Pethau Brau'. On a hill above the town the most strikingly evident statement was made by Angharad Pearce Jones, in her dramatic reuse of agricultural scrap as a comment on the changes in a rural community. Other Eisteddfodau have been host to time based work, such as performances by Marc Rees (1992) and André Stitt (2001) and the event staged by Peter Finnemore and Elfyn Lewis at Llanelli (2000). The latter was based on the idea of renewal and the future and incorporated poetry, music and debates on the future set within the colourful domesticity of a stage garden shed.

I'm back in Cardiff and it's early January. I shrink into my coat, pull down my hat and feel glad that I haven't brought my camera this time. We tend to photograph art in public places on clear, bright days, when they look sharp against a light blue backdrop of sky. This is definitely not such a day and, as I meander around central Cardiff and the windy reaches of Cardiff Bay, ticking off art works as I go, I muse upon the purposes of grand civic works of art. Do they give grey-faced commuters a rush of pride and a sense of wellbeing as they side-step their way along crowded pavements or jiggle their cars across speeding lanes? Cardiff and other urban centres in Wales have changed in many ways during the last twenty years and public art has had a

Above
GWREIDDIAU/ROOTS
Angharad Pearce Jones
Hadau/Seeds
National Eisteddfod,
Y Bala 1997

Right
Sebastien Boyesen
Broadway Wall
Pontypridd 1997

Jon Mills
Caerphilly Visitor Centre
1995

Robert Camlin
and Ieuan Rees
Caerphilly Town Centre 1995

Pat Aithie

Mo Wilson

Mo Wilson

role in this transformation. The nature of these changes must have been due, in part, to the effects of seventeen years of Conservative government and its propagation of an enterprise culture. The effects of this regime on public art were not unique, as there is an historic connection between the demonstration of civic pride through public art and its use to celebrate industrial and economic success. However, during the last quarter of the twentieth century such an association could sometimes be seen to be a source of conflict between the perception of public space as belonging to local people or users and its control by local authorities, development corporations and large private and multinational companies. In the 1980s and 90s there was a significant increase in the demand for art in public places and for the services of the Welsh Sculpture Trust and of other agencies to manage projects. This close relationship between the political climate and the demand for art in public places inevitably influenced the nature of some of the artwork commissioned.

It was partly as a response to this demand that the work of the Welsh Sculpture Trust was expanded to subsume the Welsh Arts Council's commissions service and for it to become the effective public art agency for Wales. In 1991 The Trust changed its operational name to Cywaith Cymru . Artworks Wales as an indication of its new professionalism in managing projects across all the visual arts and crafts disciplines. The impetus for urban regeneration also provided a direct stimulus for the placing of art in a variety of public situations in Wales. These ranged from the production of complete strategies for public art as part of a town renewal scheme (Newport) to major single interventions, such as the Pontypridd Broadway mural. This focus extended the number of agencies involved in developing and managing public art projects in Wales and while Cywaith Cymru has continued to be active nationally, Cardiff Bay Art Trust and the Design Team attached to Swansea City Council during the 1990s also realised specific local development art projects. During the 1980s there was a preoccupation with the levying of one per cent for artwork from the budget of major development schemes, a strategy which was seen to be especially successful in the USA and which has been adopted on an occasional basis in Britain, although this practice has never been enforced by law.

As I was growing up in Llanishen, a village, which during the 1950s changed into a suburb of north Cardiff, Caerphilly was the town just over the mountain, to which we sometimes rode our bicycles over the challenging Thornhill route. This time I chose to travel on the train, which tunnels its way in alpine style until it emerges into the other world of 'the Valleys'. The centre of Caerphilly is a long shopping street, curled around its medieval history in the form of the blackened austerity of its castle. Second only to Windsor Castle in overall size, it has occupied the prime site for urban development for about 1,000 years and has made modern Caerphilly an awkward, lopsided town, defying efforts to create a real centre. However, through a project managed by Cywaith Cymru, artists, working alongside the landscape architects Camlin-Lonsdale, have been involved in the plans to give Caerphilly a more attractive urban character. A

series of defined spaces swirl down the slope, controlled by steps and railings and punctuated by sculptural pieces, stones incised with feather motifs and texts and culminating in the 'Table of Innocence'. This stone table, carved by Ieuan Rees, bears the thoughts of Sioned, aged 8 about things that she might strive to do, '...to hold the air, to weigh the world and to stop time'. She is someone who might in future stand at that spot, look at the ancient castle that dominates her town and contemplate the mysteries that are expressed through images and words and understand the value of placing such things in the public domain. To me it seems that Caerphilly is a town caught between a violent history, a drab present and a desire to state its optimism about the future. The tourist information centre is designed to be the most exuberant building in the shopping precinct and from its balcony I enjoyed an elevated view of the impressive castle. The experience was enhanced by the daring and almost precarious slant of the balustrade. The marvellously baroque design of interlinking flying arrows energetically suggests scenes of conflict, and the noisy turbulence of war.

Walking back through the castle grounds, the green domain which CADW guards, I want to see interpretative art works here as well, making links back to Caerphilly's other histories and its present, its mining and its people. I think about the artists who have made the things I've seen, Julie Westerman, who crafted the bronze birds on columns watchful over seated alcoves in the urban space, Meical Watts' quiet carvings and the belligerent railings forged by Jon Mills and I wonder at the ideas, the skills and the commitment that distinguish a generation of artists that has grown and matured since 1981. These men and women are rarely well known by name, except by those who work with them. They tend not to be given the same status as artists who exhibit their work in galleries and who are recognised as part of a cultural elite. Instead, they bend their imaginations to the work of making our shared environment a better and a more stimulating place.

Regeneration has become one of the catchwords of post-industrial Wales and various organisations, such as the Groundwork Trusts, have also engaged artists to work with communities in physical, social and economic reconstruction. This work has frequently involved landscape renewal, following the clearing of industrial sites, such as coal tips and steelworks. In this context artists began to work with landscape design teams, as well as with architects and planners. In 1990/91 the Welsh Sculpture Trust, with the Welsh Arts Council, tested the waters of this type of professional collaboration when it was responsible for devising cross-disciplinary projects for the Ebbw Vale Garden Festival (1991). More recently, a major example of an environmental regeneration has been the construction of the Llanelli Millennium Coastal Park (2000). Artists have worked closely with landscape and environmental experts to develop and interpret the transformation of the derelict landscape left by the steel mills and tinplate works that previously flourished there. A significant part of this new landscape is the development of the Wildlife Wetlands Reserve at Penclacwydd, where

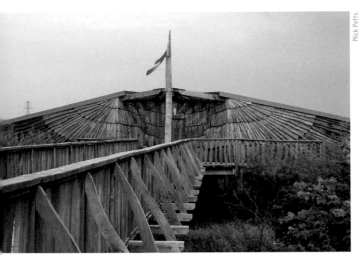

Mick Petts
Heron's Wing
Gateway Hide
Architects: Acanthus Holden
Wildlife and Wetlands Centre
Penclacwydd, Llanelli 2000
Swans' Nest
Earth Sculpture
Millennium Coastal Path, Llanelli 2000

Mick Petts was commissioned to work, continually crossing the definitions of sculpture, interpretation, landscape and utility. The visitor enters his sculpture, the Heron's Wing Gateway Hide, which is both sculpture and observatory, and is able to look out over the banked mud ridges that create a habitat for the birds. Throughout the reserve Mick Petts has made willow screens that hide people from birds, especially designed sculptures that will serve as habitats for various species and interpretive elements, such as the giant 'Swans' Nest' in which the 'eggs' dwarf any visitors who wander into its bowl. Richard Harris also worked over a long period with the Coastal Park design team to restructure a headland, eventually leaving a land sculpture, 'Walking with the Sea', of which the massive but subtle shape of an uncurling snail is only really appreciated from above and at a distance. However, for the people who can use its cambered curves as a cycleway, there is an entirely different sensory experience to be had. In another major land sculpture 'Two Rivers' by Richard Harris (Wrexham 1999) the artist has entirely taken on the role of landscape architect in his remodelling of an area of land near to the Gwenfro River.

Whenever I travel around Gwynedd I am struck by the strange anomaly that here in this part of Wales, mostly valued for its landscape quality, some parts are dominated by ugly reminders

of its past value as an intensive industrial area. The National Park has discreetly made its boundaries to just exclude the remnants of the slate quarries, which must once have given its people more employment than farming. The people who live in Gwynedd are still mainly clustered into the five 'slate valleys', where housing is plentiful and cheap. It isn't surprising therefore that in the Slate Valleys Initiative, Gwynedd has launched a campaign to offer revival or regeneration to these places. I discover that the formula is similar to that being used in the other areas of regeneration, with the emphasis on kindling self worth and optimism within communities and upon new tourism developments as the focus of economic sustainability. I was in my teens when I first visited Blaenau Ffestiniog, straight from Cardiff and having little familiarity with the rest of Wales. I fell in love with the extraordinary landscape and spent several happy weeks with a group of young people during which we were encouraged to do exactly the kind of activities that are now writ into the sustainable tourism handbook. We were taken on walks around the derelict slate quarries above Manod and explored the lovely Vale of Ffestiniog, then proudly referred to as 'the Switzerland of Wales'. We learnt about local life and history and got to wander around the town of an evening, talking to local people. Going back now it is to visit the Manod Slate Yard to take a look at the slate slabs carved by Meical Watts and Dominic Clare, waiting to take their places as markers for the walks I once explored. Ever since that first time I have found the quarries both thrilling and threatening places and I have the same experience today, venturing on the 'Wheel Walk' behind Aberllefenni, near Corris in the most southern of the slate valleys. I wonder if other walkers will shudder and peer cautiously at shattered tips and gapping caverns as they wander along. I gain confidence about being in this environment from the huge slate slab, decorated in an almost cheeky way by Dominic Clare, which marks the start of this walk and announces its title. He has jammed a small iron wheel into the hole cut into the slate and, to spell out the name, inset tiny red glow worm beads of the type used on road signs. I discover that Dominic, like Meical Watts has been busy running workshops in schools, making way markers and other sculptures, using artworks to make visible the spirit behind the initiative.

To visit the slate valleys will always put me in mind of Paul Davies, the charismatic artist and teacher who died in 1994. He would certainly have been involved in some way with the Slate Valleys Initiative. I remember well a hairy evening walk through the huge mines behind Bethesda, when we clattered interminably over banks of slate refuse, peering into dripping, fractured holes and discoursing on the possibilities of a massive sculpture park arranged around this awesome landscape. Paul's energy and enthusiasm were phenomenal and he was always pushing the Welsh Sculpture Trust and others to tread a thin red line by committing to projects with risk and with vision. He set the foundations for the practice of land art in Wales, although only a few of his major proposals were actually made. His somewhat literal use of the shape of a map of Wales in order to interpret

Stephen West

Dominic Clare
Slate Valleys
Gwynedd 2002

what is happening to our country became famous during the 1980s and his temporary 'Mud Map of Wales' created at the 1986 National Eisteddfod in Fishguard is known to many people. However, less well known is the conservationist map of Wales which is sited at Llyn Alaw in Anglesey (1987), an earthen model large enough to walk upon and home to the indigenous plants of the locality.

Even art works, such as that at Llyn Alaw, leave a footprint on the natural environment, although some are designed to impose only a faint trace and to change and even vanish over time. In some respects the contemporary concern with the sustainability of natural resources and of community and cultural values is at odds with the drive for urban development and the acquisition of land and resources for that purpose. During the last decade or so artists and the managers of public art projects have had to deal with these dualities and to make some sense of them for the public. One of the fastest growth areas for artists engaged in public practice has been the demand for work in a variety of countryside situations. Most frequently artists are expected to both embellish the landscape and to provide interpretative clues for the public. While such projects are admirable in their aims, their individual success must be open to discussion in the light of long term issues of impact and conservation. In 1989/91 the Arts Council of Wales worked with the Woodland Trust on the Seats in the Woods project and subsequently many environmental projects have involved artists working with local and natural materials to make seats and markers in forests and woodland and along walking and cycling trails.

More challenging have been certain 'site-specific' projects, which have sought to uncover or reveal the sense of place. Ian Hunter's haunting 'Lake Sculpture' (1986) at Margam Park set an interesting precedent when he made a full size reproduction of the gable end of an historic chapel that was sited on the

Margam Estate. The sculptural building was woven from willow and stood on a raft in the lake, as if a reflection of the true building. After one year of graceful and haunting life the sculpture was ceremonially burnt on Midsummernight, now symbolising the passing of history and also a refutation of the human tendency to impose objects on nature. Michael Fairfax's sculptures in the Garw Valley Forest (1992) and Alain Ayers' 'The Eyes of the Sea' (1990) were also outstanding examples of sculptures which interact with place and with history. In both instances the artists created a series of pieces which lead the visitor through the chosen area and which also hint at the unravelling of a narrative about the past history of the place.

It was in search of some of such works that I continued what has begun to seem like a pilgrimage to revisit special places, which should refresh the spirit. A trip to Pembrokeshire always has the character of a pilgrimage as it is difficult to avoid the aura of its sacred and ancient places. Perhaps, for some of us, long distance walks have taken the place of pilgrimage, driven by the desire to complete the route and to be able to log the credit. When I first saw 'The Eyes of the Sea' at Millhaven over ten years ago it had seemed rather like a wayside shrine. The 'eye' on the beach was an inviting enclosure where I could sit and watch the Stack Rock shimmer in the distance. The stone sparkled clean on a bright summer day and marked the place as special, with a sense of history. Millhaven isn't easy to get to and so these stones are really placed there for walkers rather than casual trippers. They are intended to make them stop, look and

Simon Fenoulhet

think. On my wet and windy pilgrimage back to Millhaven this spring I had to look to find these 'eyes of the sea', now grown over, lichened and mellowed. It was reward enough for my searching that they are still there, but my thoughts turned to the question of who takes care of our artistic 'shrines' and to whom do they now really belong. Have they too been discarded in some fashion, used and forgotten by our careless, throwaway culture? Will some of these sculptures be rediscovered in time and treated as a part of our heritage or will they just be allowed to pass with dignity into the disuse of so many human artefacts?

I hurried back along the green lane to my car as drizzle started, surprised by meeting with one family of walkers setting out for

Martin Roberts

Millhaven and wondered if they would perhaps pause long enough at the stile onto the cliff path to feel the slight indentations in the upright stone, the traces of the outline of hands belonging to the local farmer and his family. The modern pilgrimage tends to be motorised in its mode of travelling and cursory in its reverence to sacred places. I followed this example in hurrying off to a more urban spot, to look at the 'Landsker Cross' made for Narberth by Howard Bowcott. The tall, wheel-headed cross was a solemn symbol on this grey day, fashioned in the sculptor's personal way of fastidiously stacking slate pieces. Here there is a reassuring calm, a clear link back to past monuments, but new in its form and the particular craft, careful to avoid parodying history. 'Landsker Cross' is surrounded by the usual jumble of buildings and road signs familiar to small towns and I concluded that it was a mistake to place it in this particular situation. I hurry off to find a cosy café and to think about the way that Narberth must have changed since the time when the site of 'Landsker Cross' was perhaps really a place to stop and meet with other travellers, exchange news and enquire the way.

Left
Michael Fairfax
Song of the water bowl
Garw Valley 1992

Above
Alain Ayers
Waking Eye
Millhaven, Pembrokeshire 1990

7 1

Iwan Bala

Simon Fenoulhet

We have our own reasons for going to places of pilgrimage and just the getting there may be enough. This is certainly true of Ynys Enlli (Bardsey Island) two miles off the coast of Llŷn, where I went once, a long time ago, crossing its dangerous sound towards the beckoning pile of land. In some respects no artwork here could be public in the permanent sense, but has to be conceptual, re-establishing the meaning of the island as a place of spirit, emotion and worth. That meaning is as much for its nature conservation value as for the holiness that was once associated with 'the island of twenty thousand saints' and the artists who have been working here recently have responded to both aspects of the place. Cywaith Cymru has established a five-year series of residencies on Ynys Enlli, a National Nature Reserve. The first resident (in 1999) was Trudi Entwistle, whose ephemeral pieces of work interacted with the natural and human processes of the island. The poet, Christine Evans, herself one of the tiny resident population, described the work.

Most pieces were to be found at the sea's edge, as though the greatest challenge lay in this most transient of environments. A row of 'limpet eyes' stared up from the tideline, the shell tops eroded into holes. In a shadowed gully, bleached driftwood became a ladder or a walkway; arranged in three crescents on the beach it glinted white as teeth or whaleribs, and while to me – watching the play of shadows as the light changed – it suggested fossil life, children were inspired to run sticks along it, playing the swirls like a giant xylophone...

Howard Bowcott
Landsker Cross
Narberth, Pembrokeshire 1994

The next year Ben Stammers went to the island to take photographs. This was a trip back to his youth for him, as he had frequently visited Bardsey from his Bangor home. He recorded detail, evidence of current human use, almost metaphysical images of places where people had been and things had happened. Then in 2001 a textile artist, Claire Barber, worked there, bringing with her an interest in the land and installation work, as well as her skills with wool. The sculptures that she created were felted shoes, made from the fleece of the Bardsey sheep and moulded onto the feet of the few children who still live on the island.

Spring is early this year as I make my final visits on my journey around Wales to look again at places where art projects have been carried out and art objects have been placed over more than twenty years. Antur Waunfawr in Gwynedd is buzzing with the activities of the members of the project as they develop and care for the gardens and woodland walk, serve in the café, make ceramic pots and greet visitors by insisting on asking from whence we have come. I drift lazily around this pleasant place, a soothing detour off the uninteresting stretch of road that leads away from the impressive aspects of Snowdon's flanks and the towering Nantlle ridge towards the uninspiring squash of urban developments around Caernarfon and Bangor. Here at Waunfawr a community has got together to turn things around and made this centre, where mentally disadvantaged people work and where everyone has the chance to take part in a creative project. The sun plays with fey charm across the surfaces of David Lloyd's sculptures on which he has carved birds, insects and plants. In some respects the sculptures seem as delicate and transient as the things they represent, in other ways they exploit the hardness and longevity of the wood. In contrast, the stern memorial to John Evans, Waunfawr, carved in low relief by Meical Watts, demands a pause, to look and puzzle at the iconic figure of a naked man, with upraised arms, which seems about to cast itself face down in the shallow trough of wetted stone that is both its resting place and its tomb. It is only with difficulty that the shape of the trough becomes that of a boat and yields up its association with the story of Evans and his quest for the Mandan tribe of 'Welsh' Indians in far away America. History is full of mysteries and the search for this 'lost tribe' is one that touches the imagination and affords a sense of sadness to my visit to Antur Waunfawr that is matched by the gravity and strangeness of the sculpture of 'The Lonely Man'.

I drive away from Waunfawr with the thought that, although art in public places may conjure an image of bulky sculpture sited in a shopping precinct or outside a public building, or of gleaming stained glass windows and murals jauntily jazzing up gable ends, it is also about helping people and communities to realise their own creativity, to explore their own sense of place. Artists throughout Wales have become facilitators in the process of the empowerment of communities and of their realisation of identity. This activity is in harmony with a worldwide valuation of the local and the indigenous and of the broader environmental thinking seen in documents such as Local Agenda 21.

Community art practitioners, such as the Pioneers and the Bethesda Group have already established a reputation for this kind of work, especially in the south Wales valleys. At present the need for regeneration in rural areas is causing an upsurge of arts projects, which define identity, instil confidence, support sustainability and even open up ways to advance economic growth. In 2001 I made my own step forward when, with Lynne Denman, I set up Creu-ad, an artist group committed to working with communities in Welsh-speaking rural Wales. Through such initiatives, art in public places can encompass many ways of working and can become part of a process and a bridge to new ways of collaboration. This optimistic thought comes to me as, one cool, clear evening in April, I linger nearer home, leaning on a gate to look across the Dyfi, through the shining, wavy metallic dashes of Millennium Bridge, designed by Jon Mills and Bruce Pucknell and commissioned by Powys County Council to take the Wales Cycle Route over the river. It will suffice, I think, to be my chosen symbol of this connecting role that we have forged for art in public places.

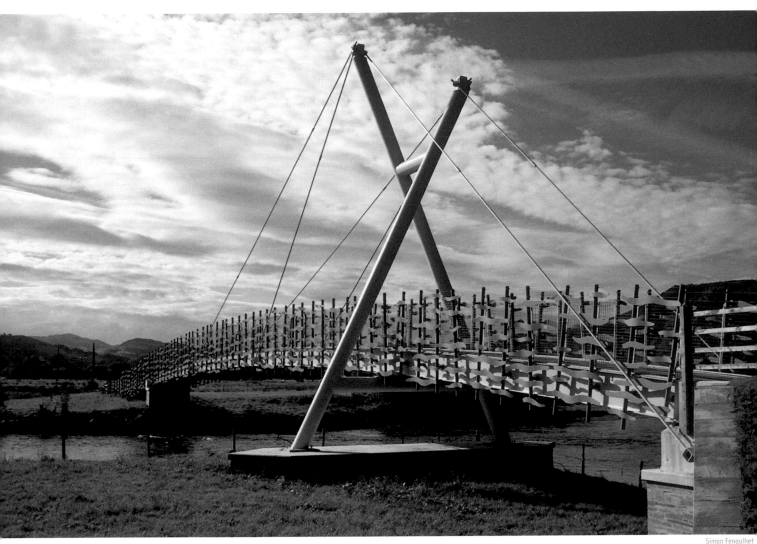

Simon Fenoulhet

Jon Mills
Dyfi Millennium Bridge
Machynlleth 2001
Engineer: Bruce Pucknell

public art as vision, praxis, civitas

john gingell

THE PRACTICE OF THE ARTIST/DESIGNER IN THE CITY: A
QUESTION OF RESPONSIBILITY.

The business of public art is usually discussed within the closed circles of 'the art world'. I want to open this up and look at the context within which the practice of public art takes place. I will look at my own experience as an artist and raise questions which my practice has encountered. This is prompted by a sense of conscience for the realities which arise at a social level.

The realm of action in society is now the urban, the place where most of us live. Our lives are rendered complex by its very nature. We have to talk about the society which the word 'city' now means. A realm of interaction as a teeming, connected and wired matrix of motor-borne, intercommunicating worlds. Public Art infers art which is placed somewhere out there, beyond the gallery or the concert hall – out there where we meet, mix, drive and resort. In the last fifty years, the term public art has moved from the notion of the 'plopped down' deposition of discrete objects in squares or on institutional facades to take on the socially interactive context of the community. Art in the twenty-first century now presents itself as a heterogeneous mix of embodied objects or specific actions, both permanent and ephemeral. Discourse as to meaning and responsibility has embraced the question of 'for whom? Public Art lies now at the centre of the interaction of power between the civic authority of the city and the commercial operations of corporations and multinationals which operate in the urban space. The questions concerning society, community, the individual and the mass cannot be seen as independent from the act of art within the public space.

The professional artist-designer is engaged in the business of *vision* in the city. As an operator in the public realm, there is the general responsibility to act 'for the public good' – to make things better. The artist thinks and 'imagines' as a part of this process. That which can be 'imagined' can be created and made. It is a question of thinking in a particular way. Such interventions take place on location, with a disputatious audience. Society presses around us in the 'city' where we all now dwell. This 'city' is a place of flows. In modern terms, it exists at the rapid intersection of information where people gather to exchange goods, be secure, make love and families, store information and gold and to gossip. From the speed of the marketplace whisper to instantaneous electronic flows, conceptually this is the city

John Gingell
Lightpoint
Baglan 2002

that the thinking mind and body inhabits. So there exist simultaneously the physical city and the invisible soft city; connected by politics, powerplays and social emotion.

John Gingell

They exist independently from, yet associated with, the 'official' city of buildings, corporate institutions and the centres of government, law and knowledge. This is the city where we work. It emerged from the histories of Rome and Athens; models from which our city societies, our democracies have descended.

The artist is faced with a playground – the geography of her/his imagination. Those involved in public art as artists are paid to have vision, to build, to oppose, to comment upon, this terrifying realm of urbis – the conurbation. We live in these exciting, pulsating, choking, terrifying places – and we can see visions of how it can be other than it is.

Spreading out like Barcelona or Rotterdam, Manchester and Paris from their 'city' centres – we see time in change. We now live in an Einstein-like mix of different times and spaces, with the city existing at myriad levels: part of the global brain. We live in hyperspace, disconnected from the primary sources of land, able to buy resources in the endless 'supermarkets' of provision which the city brings. This is the freedom envisaged by the social reformers of the twentieth century. The individual, often suffering from psychological dissonance and a perverse sense of alienation, lives in the world of endless possibility and a bewildering range of choices. Meanwhile, for those without education and the means to command the finance required for consumer citizenship, crime and drugs provide relief – and open up the gap between those who have and those who have not. There is a large Third World in every large city. This is the dichotomy of city life – the twin to this is mirrored in the huge immigration and asylum movements now emerging as instant televisual and netscape images worldwide inform the impover-ished of what they do not have.

New York City Parade
USA

As an artist of some years; and in recent times as a public artist engaged on large projects, I reflect on the dilemma of one who is involved in well-meaning projects for the betterment of the public realm and principally of prominent sites in my own and other British cities. I was schooled as a student in the ideals of beauty – at their best received via the Renaissance from the Greeks and the Romans. Beauty is a vague and grand concept which links the public and private life in notions of the sublime, and the harmonic and of having to do with an indefinable but real sense of truth. The artist historically, and more recently the designer, is connected to the celebration of human life – a rewriting of the power of the body with the spirit. Each work, be it poetic, musical or of the artefact has to do with a mastery of the human capacity over the brute nature of material, the encapsulation of the will and spirit over that which prevails in nature. The conquering of time and circumstance by desire.

Hobbes and Locke said: 'While we live, we have desires' – life is a state of desire predicting that therefore there can be no such thing as harmony. We are covered with the narrative we tell, walking as we ever attempt to do, to walk backwards to the happiness we crave. The Renaissance set the question of what is it to be human – a subjective quest – as against the objective state of mind defined by Plato. The discourses of the West since the re-birth have been exercised by the question of the metaphysical psyche. The great issues concerned with building a city culture are driven by going from 'being' to 'doing', a utilitarian notion of measuring 'good' by action as opposed to the Romantic view that all is loss and decay, to be overcome only by an act of will, and withdrawal.

This 'spirit' of the city – civitas, is distilled and defined in the universities and is the legacy of the argument for knowledge and its application. Within the walls of these power houses, new technologies and social models are constructed which redefine the city as 'people', 'clients', 'consumers' and argue for such 'publics' with varied agendas.

The new technologies are digitally driven by chip refinement and by the development of artificial intelligence within the machinery of the computer. There is a corresponding endless virtual possibility within flexible materials which can be deployed to construct any conceived idea – in products, architecture, fashion and entertainment. The use of intelligent molecules and polycarbons are now part of the ferment of city academics and the talk of those who understand. But these developments have not yet changed the reality of the daily life of most people which still relies on confidence, community and security. Every city is besieged with advertising and at home, television shows the goods, services and things which only money can buy. Urban commercial violence mocks the dreams of those of us who know.

Whilst we sit in our conferences and seminars concerned with the 'good' of the city which our profession denotes, in Oporto, a new billion-Euro bridge is being constructed across the Douro to link northern Portugal with the European motorway network. People are living in abject poverty in tin shacks, adjacent to the site, stuck to the side of collapsing river banks with no sanitation,

John Gingell

privacy, nor piped water. It is difficult to reconcile the concerns of aesthetics, beauty, the good in communal civic terms with such dilemmas of reality which exist in each city.

The city is called the global village; become of the immediacy of communication which has shrivelled distance. The city is no longer merely the seat, or cathedral of the bishop. The 'city' is suburbia and the metropolis is a swarming mass of ringroads and infills. Barcelona is a good example of this growth – 'up to the motorway' – or in Britain, to the edge of and through the 'green belt'. The city is now miasmic in pattern. City is megalopolis, no longer physically bounded, a lattice, a network of infinite interfaces; 'named' global nodes, historically linked to a geography, a location. *This is the machine where we all now live.* The 'hypercity' is the financial and economic trading space paradoxically 'virtual' but also 'real' – a place of the gods who control and affect all our lives. In this present place, there is a

John Gingell

Top
Long-term shack
housing,
West bank of the
Douro, Oporto
Portugal

Bottom
Railway platform,
Oporto
Portugal

breakdown of the 'real' of the city which was its original function. The old city was a place of law and order where man met God, exchanged money, goods and services in security – housing, architecture, banks, banking, merchants, priests and thieves – and therefore was also a place of disorder, crime, poverty, ill-health; a squalid hierarchy of the many in ranks and castes supporting the few who held power. Palaces and tenements, spas and charnel houses; power, parade grounds and plague pits; the realm of potentates and dictators.

To operate in the field of public art and design is to be concerned with the pressing social and moral questions of our time which compete with our projects for the streets of the city. There are ethical and moral questions which impinge at least and in context enter in to the heart of the matter.

The city is power and politics, control and surveillance. It is the city of Kafka and the alienation of self from self. James Joyce, who living his life suspended in the cities of Europe, fled from the Dublin of his *Ulysses*, and acknowledged his debt to the writings of Edouard Dujardin – particularly his filmic direction compounding of time and space into a virtual reality in his book *The Bays are Sere*.[1] In the opening pages, we are drawn to the city of Paris viewed as a place in a million separate incidents played out in an arena called 'Paris'. Dujardin's text runs like a viewing camera, tracing the weave of incident like moves in a film. We have become the inhabitants of such 'scenes'. Life has become 'kinematographic'. We live as much in the film world, transported to an imagined 'knowledge' via the eye. We construct personal myths which extend our lives to endless realms, which we can write or re-write at will.

The city has changed its rhythm. The automobile has deepened the crisis. Speed, the essence of the Futurist vision of the city as megalopolis, now dominates our urban lives. The time-mechanism, the car, individually transporting us in from home to business, in and out of the city, compounds its restless, poisonous clamour. The vision of a city-state in the film *Blade Runner*[2] reveals the future as a supra Los Angelean construction extending outwards to encompass the 'paysage' and upwards into a stinking, dripping, entanglement of decaying town, creaking antique technology and multinational economic political consumerism, shot with legitimised state violence. We live somewhere in between this, not yet totally economically driven, held in some way by a notion of city virtues that the Greeks and Romans held to personify the city. We still have city councils – to whom an increasingly smaller role is given for 'virtuous' enactments, education, drains, leisure and planning.

I have completed a number of projects in city centres – at the heart of the matter. The complexity of sites, context, audience and critique have arisen in each case. Of course, as part of my practice I welcomed the opportunity to engage in challenging commissions. With the passage of time, my thoughts have had to take on the issues which arise from the acts of my art making and with which this essay attempts to identify.

As a result of European Union programmes to promote art research and develop new teaching, I was invited in 1990 to join

a group led by Dr Antoni Remesar of the University of Barcelona concerned with cities of the waterfront and their reconstruction. This group, the Public Art Observatory, has engaged academics and practitioners from port cities, for example Helsinki, Rotterdam, Exeter, Oporto, Lisbon and Cardiff. Conferences, seminars and workshops are held each year to focus research and activity. My connection and contribution to this group broadened my perception of art in public and has developed in me some sense of the complexities to be engaged with by artists and designers, as part of increasingly interdisciplinary studies, projects and actions within the cities of Europe. I have lived and raised a family in Cardiff for nearly forty years, occupied as a teacher of art in the local college of art. With the development of Cardiff Bay came the opportunity for artists to engage in a range of art projects for key sites in this big enterprise to reconstruct the old dock area and, with a barrage across the estuary of the River Taff, create a dynamic new town on the waterfront. This is now history and the Bay area of Cardiff is part of the new city with the new Assembly building near completion.

My involvement began with a commission from the then South Wales Electricity Board organised by Cardiff Bay Art Trust, prompted by the percent for art scheme levied on all commercial enterprises in the Bay scheme. It illustrates the key role given by the Development Corporation to the value in commercial terms of the 'civitas' invoked by artists working in

John Gingell

public space. The 'new' city was convincingly seen as engaging the 'virtue' and civilising demonstration which art could bring.

Prior to this commission, I had worked on two sites which helped me to develop work as 'sculpture' but which essentially were a 'work in place' taking on the whole site. This involved long-term work in the place itself – so studio and a place of deposition became one. In the 1970s, I had carried out performance art, and I now saw this activity as a kind of slow 'performance' engaging the sculptural elements, the processes of the community in which they were set and my activity as the constructor, working together to create the 'work of art', the object as image emerging slowly in the theatre of operation.

The first of these projects took place at Llanover Hall in Canton, Cardiff, in the late 1960s. This had become an active Arts Centre based in the house itself and an adjacent theatre building. The site offered to me was a strip of grass in front of this building and adjacent to the main arts centre. It had also in war years been the location of a public air raid shelter for the street. It seemed to require a magical restoration. The key for this was a phrase which had echoed in my head from school days: "Childe Roland to the dark tower came"[3] – this seemed somehow related to the notion of young people coming to Llanover Hall to be creative – each of them seeking something essential for their present and future time.

The local authority donated five lorry loads of demolished houses from a nearby street and they were dumped onto the grassy patch. Overnight it became a huge pile of smashed rubble – the 'bombed' past of Cardiff to be sorted and rebuilt into the Tower – a 'real' symbol of the phoenix emerging from the ruins. The stones used for the outside walls were old granite sets removed from a main road under repair, former supports for tram lines. The material was free and for nearly a year, I spent time sorting and stacking bricks, wood and dust. The dust was used as a fertile source of earth for the banks of the site which were planted with daffodils.

Slowly I built up the tower and its surrounding access paths which snaked away to and from it. As the structure emerged, my work as a mason to build it led passers-by to assume I was unearthing a structure which had always been there. The 'uncompleted' or 'fallen down' tower was left at about fifteen feet and as a whole provided a 'theatre' for outside performance from the theatre behind and much running-around fun for the art students. Visually, the work was a trick. The completed work looked like the 'oldest' building in the street, around which Llanover Hall must have been built. It took three years to complete. Quite recently, after twenty years of life it has been torn down to make way for more car parking at the centre. Even in this last act it performed its part in the great drama of the city and became, like Rome, hidden under the tarmacadam.

The sister to this project was undertaken at St. Joseph's school in Newport. The school is built on part of the Tredegar Estate there. As a Catholic school, most pupils arrive and leave daily on buses which collect them from the country. The circulation of buses into the school was provided for by a triangular 'round

John Gingell
Work in progress
Llanover Hall, Cardiff

John Gingell

John Gingell

island' in front of the geometric school of 1960s style. Upon this island of grass grow several magnificent exotic trees, part of the famous collection gathered in Tredegar Park by the owner of the house in its heyday of Victorian grandeur. This was the site on which I was commissioned to 'make a sculpture'. Once again, I saw the whole site as the canvas of the work, to be drawn into vision. The children in the school moved from level to level of the glass structure to the summoning tune of the school bell ringing the period changes. There they were being staged in the machine of order and control. Opposite the school on the other side of the road, stood a sheltered housing complex for the elderly, who day by day witnessed the ebb and flow of their former selves coming into the school and then leaving at the end of the day. The space of the site seemed to call for a structure which challenged the rectangular horizontality of the contemporary buildings and texturally conjoined with the rich bark patterns of the majestic trees isolated there. All windows from the school on one side looked down onto this becalmed arboreal scene. The school governors, the then Welsh Arts Council and Newport Borough Council raised budget money and enlisted material and technical support from local firms.

I set out to work on the project in school vacations in the main, for safety reasons. I designed a series of curved walls to make enclosures around the trees, with a central tower of two raised stone walls pointing up to the sky like the trees and cut through with a gap to allow equinoctal sun to shine through and strike a sunray to the centre of the school site. Yet again, my work (assisted by school volunteers and community service offenders) was a committed performance of slow daily labour and emergent forms, carved out in full view. I obtained twelve lorry loads of stone from the old brewery in Newport being demolished and they were duly dumped near the site. Again the long sorting of piles into re-usable material. Bricks came from the last brickworks in Newport, now closed. The idea was to use the ale house to carry with it a strong textural challenge to the omnipresent glass and plastic of the existing buildings. Apart from the outstanding challenge of the pylons at the centre, the enclosures of brick were to provide some privacy for the pupils at break times. The completed work took four years of inter-mittent labour and resulted in a dynamic time-engine of subtle light changes and shadows from which the canopy of the trees sprang. And every day, the round of buses encircled what became a sacred, protected glade, redolent of some mystery in its strange, circular rhythms and ancient feel.

I learnt the value of becoming one of the community of the school as a working artist, bringing the work slowly into fruition; as slowly as the passage into knowledge undertaken in time within the school. For me as an artist, there was no separate mystery of making and sudden deposition. My open work in the former abandoned site, set up an image of the extraordinary, linking a former idea of arboretum to the new jazz of sudden transportation and the modern timescale of instantaneity. These two projects prepared me to take on the key commission which I won in the 1980s, to make 'a sculpture'

John Gingell
Place of Stones
St Joseph's School
Newport 1980-84
Top
Life Chamber
Bottom
Central Pylons

in the SWEB sub-station at Tyndall Street in Cardiff, organised by the Cardiff Bay Art Trust. The Trust had been set up as part of the Cardiff Bay Development Corporation to guide and manage the policy to use art in the Bay area at key sites. With the enlargement of the City of Cardiff to the waterfront, came the envisaged need to increase provision for an assured supply of electricity. For strategic reasons, the old sub-station at Tyndall Street was to be upgraded by the provision of high technology power transfer units to be housed inside a new building on the site. This would mean the demolition of the old familiar ceramic insulations which occupied the majority of the site, leaving a cleared space. The commission was for a work of sculpture to be placed in this area.

I soon realised that the site and its engineering structures within the protective fence was unique. Most public art is under wear and tear almost from the moment it is placed 'out there', in the plaza or street. Graffiti, physical damage and lack of maintenance add to the sense of rejection offered by the general public to such 'high art' deposited in their midst. I was excited by the tough and salient position of the sub-station. A key inner city commuter road to the Bay swooped along and over the western side and a busy feeder overpass along the south side. The site was a no-go area for the public by its dangerous nature and yet could be seen from all sides by pedestrian and driver alike. I proposed to the South Wales Electricity Board that they allow me to 'sculpt' the whole site and to treat the totality as a 'work'; a treatment to the site, fences, the new building and the existing structures. The proposal was eventually agreed and over the next three and a half years, a design team, made up of myself as an artist, an architect, contractors, SWEB, CBAT and Ove Arup, worked to complete this large undertaking. Key to this project was the computer imaged design provided by Art Station, the innovative art consultancy led by Glen Davidson, which made possible the realisation of what, for me, was a huge and complex undertaking.

There were four main elements to the work: a designed

John Gingell

building as a plinth to a striking 'sculpture' flying across the top to contribute a positive symbol to the city of 'electric power'; a switch housing complex, 'caged' in blue mesh across which flow a jet of darts; the third element was the treatment in colour to the fences and other electrical installations; and a light tower to express the real function of the station. This last piece was not built. It was a casualty of a review of affairs consequent upon a change of ownership. SWEB was taken over by Hyder and the project was brought to an end. This work was very important to me. It established the reality that art and design can work at large industrial scale. I, the artist, enabled the complete trans-formation of a heavy industrial plant in the heart of the Bay. I went through the experience of co-operation with complex disciplines and learnt to stand back and to take my place in the collaboration which made it possible. I became the director of the 'idea' and maker of the final image conceptually. In recent years, the making of public art has moved essentially from the auteur, creation by a single artist – to project-led undertakings by interdisciplinary teams in collaboration. This approach ranges from the operation I have outlined at the Bay to the innovative, socially immersed practices developed by artists in California like Lipkis, Fletcher and Hull who have moved art practice in the public realm to the edge of social action at street level. A form of radical non-authored communal action redefining environ-mental sustainability from the neighbourhood up. Inevitably, the practice begins to define an alternative to the classic operation of statistical official solutions and this becomes politically challenging.

John Gingell

Left and Right
John Gingell
Blue Flash
Sub-station,
Tyndall Street,
Cardiff

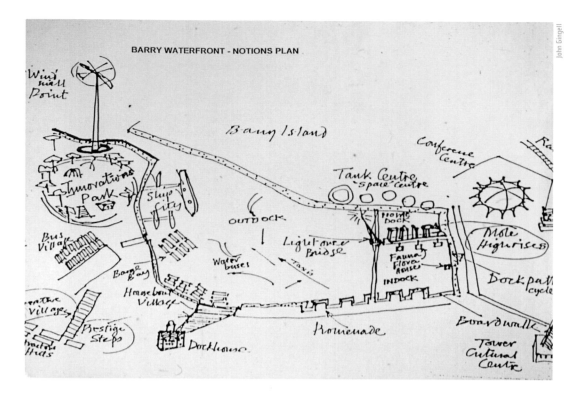

The processes of urban development and regeneration must be understood in terms of its social and ecological implications for the transformation of the city to be a sustainable – cognitive process. The public artist's role in this context is to act 'on the urgency of the moment' (Helen Mayer-Harrison and Newton Harrison). The pure activity is the development of creative relationships between diverse disciplines to generate the capabilities necessary to invent solutions for dwelling-pattern poiesis.[4]

In 1999 I was asked by Cywaith Cymru to look at the development of Barry Docks being proposed by the local authority. I was charged to look at the whole 'scene' and to have first thoughts. It was to be done in a rush – in three days. It was a gift to be so free to think out loud. Not to be the artist as stormtrooper for culture, but to be a skirmishing patrol – there before the wheels moved. It was a brief romance before reality set in.

Barry is a small, late-Victorian town, huddled on a low hill surrounding a near dead dock (hardly a port) a few miles from Cardiff. The central dock area was about to be redeveloped by the same group who had, with much fanfare, completed the development of Cardiff Bay. In ten years this has transformed the old coal dockyards, into a blue lagoon harbour around which condominiums and private dwellings jostle with

commercial office blocks, and a new Assembly House for the devolved Welsh Government. Barry is smaller but of a scale to provoke the question of the role of the 'artist' acting alone like Don Quixote jousting at the windmills of possibility. In completing my appointed task, I felt a deep pessimism coming up from the storm drains of the heart. In a tactical sense it was great to be asked at so early a stage to participate provocatively – to be free to propose independently of budgets and any planning inhibitions. My immediate pleasure in the task was rapidly ambushed by the thoughts which come in upon all artists and others who 'intervene' or 'participate' in the 'space of the public' – what am I doing and for whom? The question of what can an artist do collapses before the need to be recognised as a maker, a thinker within the mechanism of possibility.

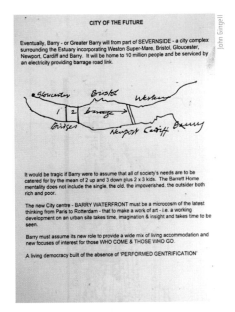

Paul Jukes talks of that other more famous Docklands development, Canary Wharf – and makes reference to a similar interaction of powers and forces acting in every contemporary development – the 'past' in the future.

> It was Docklands and its red brick road that really started me thinking that there was an intrinsic link between rapid development and the glamour of backwardness. Like the Yellow Brick Road in the Wizard of Oz, the red brick road promises a future, a new start. But unlike the imaginary highway, built on a green field site, the red brick road is built on the rubble of what preceded it. So the newcomers moving in dwell imaginatively in that past they no longer have to live with. In the dock a wind surfer slides past a refurbished Thames barge... Even the Docklands style of post-modern architecture, with its stick on Dayglo pediments, cornices and flutes, alludes to an antique style... it's not just new building you can smell here, but the new designs, new industries, new lifestyles of a global culture... the only thing making it recognisable is its nostalgia for a vanished identity: the relics it smashes into manageable fragments, pawns and parodies and makes interchangeable with any other past.[5]

What was identified in Barry was the dystrophy that affects all cities. It is the singular event like a dock redevelopment which

Top Left and Right
John Gingell
Drawings for Barry Docks proposal
Vale of Glamorgan 1999

stands out and raises the problem of 'whose cities and for whom'. None of us can really grasp the problem. Time outstrips our comprehension as great projects emerge before the artist in the public realm – and overwhelm by their complexity our ability to enter other than as a complicit actor. A dilemma is thus presented – and conformity is omnipresent. In a sense, we acquiesce. The uniformity which characterises our society begins in the packaging style, the proformas of mass consumption. A new tendency to uniformity begins in higher education and with it the education of the artist in Britain. With the absorption of art schools into the university sector has come an increasing standardisation of approach. All courses are now intensely structured. That is to say they are subject to a culture of regularity imposed via the almost universal modular system of units of accreditable learning. Effectively a packaging of procedure. There are many benefits to this. It can be defended as being reasonable that up-front transparency is provided. The student knows what is provided at each stage of learning, how long it will last, what is expected and how it will be assessed. With this gain has come the tendency of the university, bound in procedures and quality assurance and value for money to legislate only for the profitable – a 'market' (almost 'super-market') approach which leaves behind the notion of education as public provision. Inevitably minority or non-profitable areas of study are dropped. Conformity emerges as a culture of uniformity – and with it a fear of the apparent vacuum, which attends the act of creation, or more practically the performed work. Many art departments have abandoned the supreme final test of achieved work – the Finals Show and have eschewed the crisis and reality of juried acclamation, instead awarding degrees based on aggregated marks achieved piecemeal via the long chain sequence of modular marks. How does the artist or designer move from this assembly line process to the act of intervention in the working realm and thence 'take on' the 'real-politic' of competitive intervention?

At a seminar held some years ago in Newcastle, by the National Association of Fine Art Education called *Visionary Thoughts for the One-Eyed*, Helen Baker-Alder, Head of Fine Art at the University of Northumbria, asked

> What ideals drive us? If our [art] schools are built on the dated tenancies of the Bauhaus and the classical academy or on a set of diluted philosophical bywords (postmodernism I presume) does that mean that we are offering conditions so prescriptive in their rationale (the module) that innovative thought is a proscribed schema?

Most towns and cities in Britain – and my foray into Barry served as a specific local reminder – are developed on an ad hoc basis, with no sense of purpose. Local authorities are largely rendered powerless to enact a purposeful considered project. They are cashless paupers in local power – like aristocrats with no funds. They need the urban developers to fund their cities. In Cardiff, some semblance of 'planned' and accountable recon-struction is encompassed. The Bay Corporation licensed to

develop the old docklands and entry front has worked to a scheme mitigated by a sense of design and consideration. But this is at the limit of a conglomerate of direct commercial interest acting at best benignly. Inevitably, the beneficiary of this conspiracy of public and private sectors is a standard clientele of middle-class salaried professionals able to afford the lifestyles which condominiums on the waterfront provide. In living cities, all kinds and conditions of human status are accommodated in the shifting flux of the rise and fall of property, locale and scene.

In the Bay, a kind of kit has been assembled, shot through with jolly seaside nostalgia typified in the pseudo repro of lighting standards and railing. Assembled at the front lie the anodyne business parks around the Richard Rogers Assembly Building. In all, a sense of sanitised gentrification and lacklustre conformity fills the nostrils of those who promenade its empty walks. Is this really what the people need? Does this mark the new Jerusalem that the assembled hearts and minds of the good and the great at the end of the twentieth century can make – *pro bono publico*? I think not. The British wallow in sentiment – and suspect all professional promulgation as improper. At heart, the managers of big commercial enterprises who now operate in the city and who swarm to the abandoned waterfronts are suburban wannabe 'garden village' philistines who drive their bargains with paralysed civic authorities. From their sweaty desperate embrace comes a sugary effluent of sentimental gentrification in the name of 'sensitive development'. This piecemeal selling of the local family silver has prevented any real, imaginative and socially appropriate thinking at the level of innovation and care that can be seen in Rotterdam, as a new city unfurls, or in Paris – with the imagination and daring of the Paris 5 development project.[6]

Who represents the city as the place of melodrama? A realm where citizens of all standings and circumstances can enact the

Tourist Bus
Cardiff Bay

ordinary dramas of their collective reverie and passions and live in the privacy of their individual psyches? What of the poor and lowly, the dispossessed, lives outside the contract of family and recognition? How are the single, the transient, and the non-conformist to be accommodated? The current norm is one of sweeping clear and clean – and the development of the new within a narrow and unchallenged plan which brooks no delay, no redemption of the reusable, no adaptation or imaginative rededication. The customer is seen in too narrow a sense, drawn from a single species of plastic card owning, mobile phone connected passenger. Absent from the current action is long-term intelligent comprehension by those whom we have elected to understand and manage, the complex notion of what can be a reasonable, imaginative, and dynamic solution to the great task of moving the city forward – as an assemblage of a thousand constituencies of lives to be lived. The Barry Job took me as an artist on a journey from the Bay along the three or four miles which separates the City of Cardiff from its small cousin to the west. Already machines were tearing up the land. Tarmac and roundabouts were in place to connect the old town, huddled on the hill, to its new centre around the Waterfront Dock across the inlet to Barry Island. There around the deserted dock pool were the new grass swards which mark British renewal and the nostalgic reproduction lamp-posts eerily plucked from an Edwardian catalogue and deposited in the smart grass edges of the near twenty-first century. Jostling in the brittle semblance of 'my home is my castle' were the houses. Dumped there on sold-off lots in strategic sites like curds encrusting the sink after the washing up is done. Without any sense of place or scale, and in the patent absence of new or purposed thinking about the role of this dramatic possibility in a virtually undesignated site, came the depressing pattern book tide of unconnected nostalgia with badges of significance attached to them. Bath stone lintels to upgrade window apertures and thin brick garden walls marching around the assembled plots.

I started with a statement of the obvious: artists, if they survive the uniformity of their education and manage to find commissions, are glad to have work to do. But my long history of emergence from the gallery sector of art for art's sake into the real world of the city scene put me on the spot when it came to Barry. Our collective consideration of public art as fact and then more recently the discourse and politics of the artist as part of a number of interventions by social, economic and 'future-reading' agencies, has begun to throw up the need for wholescale revisitation of strategic disposition in development of which public art is often only a placebo for the absence of a true evolving strategy – and a cosmetic mask for commercial exploitation. I was asked to come up with ideas and concepts for Barry at a time when deliberation for a strategy for Public Art was ongoing. I realised the real questions were ones of radical thinking applied to redevelopment. Public Art had to be seen as part of an imaginative over-arching and ongoing plan to address the future public use of new space and the need for lighting, communication, transport and changes to the

infrastructure including the use of water itself. Postscript to the sense of defeat the Barry Job brought is to note that our failure must be seen against innovative and practical new approaches to the evolution of cities as places for all to take on their lives and futures – and addressing the whole fabric of the social and the good of the people as well as commercial enterprises. But you have to travel – by coach or by train or via the web to view the alternative. Helsinki and social housing along the water edge; Rotterdam and the Kop van Zuid, part of a masterplan of 50 years; Barcelona and the River Project of the Besos; Amsterdam and the creative industries project in the city centre: history cascades us with its models. We live in the cacophony of what we have now. We can see where it all came from as we search the crystal balls of what will be. We are before the gargantuan inevitability of our own endless commercial energy from coast to coast, from furthest promontory to garden city, the always forever-onwards push. History is littered with 'new' cities. Artists and designers have to find a way to fill the gap which Certeau[7] describes between the concept and power regulated city of order (the local authority) and the individuated walking city of people – a discourse not subjugated by the system, yet within it. All local power – the techno-economic structure – reduces the mythic qualities which the populace seeks and creates – the dream space. Certeau quotes the woman from Rouen who stated "here, there isn't any place special except for my home, that's all... there isn't anything". Nothing special, nothing that is marked, opened up by memory or a story, signed by something or someone else. Only the cave of home remains believable, still open for a certain time to legends, still full of shadows. Except for that, according to another city dweller there are "only places in which we can no longer believe in anything". The artist must rescue 'make-believe' spaces in the city which allow appropriation to the dreamtime of the traveller, the walker of the streets. "Here there used to be a bakery."; "That's where the old lady Dupuis used to live."; "Memories tie us to place." We must insert in the modern erasure of place and its shadows

> a childhood experience that determines spatial poetics and later develops its effects, proliferates, floods private and public spaces, and under their readable surfaces creates within the planned city a "metaphorical" or mobile city, like the one Kandinsky dreamed of 'a great city built according to all the rules of architecture and then suddenly shaken by a force which defies all calculation.[8]

New groupings are emerging – designers, artists, planners and thinkers, seeking to place a new thesis of sensitive interaction within the beast of the city – a new 'Jurassic Park' of possibility. If life is to be sustainable at all – then high imagination, sustained investment and poetic vision must go hand in hand. The art agency model in the UK has achieved much, providing guidance and leadership for patrons and jobs and opportunity for artists. But the real advances for the future may come from groups emerging with political, ecological and life

style agendas. In the Hague, there is a group called STROM, operating as 'a cooperative for imbalanced feasibility'; in France, a call in L'Orient for 'Paysages – les nouveaux territoires – un social-paysagisme'. In the Ruhr in Germany, this vast conurbation declares itself after independent study to be 'Number 1 in Europe for Quality of Life' – with high standards of living, excellent health care, a clean environment and efficient infrastructure for life and business. At all levels of action, changes are happening.

> Cities... are plastic by nature. We mould them in our image: they, in their turn, shape us by the resistance they offer when we try to impose our own personal form on them... The city as we imagine it, the soft city of illusion, myth, association, nightmare, is as real, maybe more real, than the hard city one can locate on maps, in statistics, in monographs on urban sociology, demography and architecture.[9]

> The city has always been an embodiment of hope and a source of festering guilt: a dream pursued, and found vain, wanting and destructive. Our current mood of revulsion against cities is not new: we have grown used to looking for Utopia only to discover that we have created Hell.[10]

St. Augustine saw the city as the source of all man's evil and wrote *The City of God* in sorrow at the state of the cities he saw around him. Therein lies the notion that cities should somehow be perfect. Lewis Mumford tried scientifically to apply practical modern analysis and thus a toolkit for the construction of the urban borne of human perfectability. This was carried out as 'town planning' – a means to the ideal of Augustine in lay terms. Hence the 'garden city' of Welwyn and the new towns of Crawley and Milton Keynes. Patrick Geddes and Ebenezer Howard developed these as radical, sanitised answers to the 'real' city – and they stand as technical wonders – but devoid of any real spirit.

> The very existence of the city, with its particular personal freedoms and possibilities, has acted as a licence for sermons and dreams. Here society might be arranged for man's greatest good; here, all too often, it has seemed a sink of vice and failure. Nor has this melodramatic, moralistic view of city life been the exclusive province of philosophers and theologians; political bosses, architects, town planners, even sociologists have happily connived at the idea of the City as a controllable option between heaven and hell. Bits and pieces of ideal cities have been incorporated into real ones; traffic projects and re-housing schemes are habitually introduced by their sponsors as steps to paradise. The ideal city gives us the authority to castigate the real one; while the sore itch of real cities goads us into creating ideal ones.[11]

As I write this, I am completing a Light Tower for a new Energy Park on a reclaimed industrial chemical works site in Port Talbot, south Wales for B.P. – one of the largest of the global giants. At the B.P. site in Baglan, I am rescued from the philosophical and moral unease which comes from being aware

that public art is so often used to palliate the conscience of commercial developers. Here, the question of restoration and redevelopment, social fairness, continuity of employment, life-long and extending education, ecological and environmental factors are all engaged.

I believe this project to be at the heart of the crisis we now face. We have the technological means to achieve anything. The expenditure of vast sums is possible because it does generate work and hope and real social regeneration. In this project, local government, the Welsh Development Agency and the European Commission, together with B.P., are addressing the real problem of regenerating a toxic site of 450 hectares, providing cheap, non-polluting power on site and providing a workplace of measured beauty and activity for the former chemical workers. Medical and educational facilities are to be built into the site. The scheme at Baglan has a design plan of ten years. Seven million pounds has been spent to restore the health of the land itself, deeply polluted by over one hundred years of chemical production and oil refining. The site will provide follow-on

John Gingell
Lightpoint
Baglan 2002

employment for the local community which lies adjacent to the site. It is a long-term approach involving on-site education facilities for the workers, a bird sanctuary of 2.5 hectares, detailed high quality, energy efficient buildings designed largely to attract alternative energy, small-scale businesses. Power is to be generated on-site by a low emission steam generator and is available to site users at a discounted rate. Business taxes are similarly subsidised. The development of this site to provide employment to help sustain a community once employed in now defunct steel works gets to the heart of sustainable joint action by local authority, government development agency and global business. Public Art sustained by a generous percent for art programme extends from way-marker pieces such as my own to ecological interventions aimed at restoring land and its dune culture at the sea edge.

My 'Light Point' sculpture acts as a way-marker to a new entrance to the site. It uses wind power, captured by its generator, to power the LED light display on the circular screw. Brunel is associated with the site and the work celebrates his invention of the screw propeller to replace sail power, here reversed to create electricity. Critics and political theorists, Gramsci in particular, remind us that artists are complicit in historical processes such as hegemony. They also carry a cultural memory, a store of traces and fragments which is a point of departure for a search for meaning which is brought back into the present. Through this, artists see the world in its complex state, and from it, they can imagine its transformation, which may be innovative and restorative. The act of art making in general, and in terms of this essay, public art in particular, is to be seen as affirmative. Even in its darkest moments of introspection, art stands as a critique and, more deeply, as a statement of the creative persistence in the midst of convention and acquiescence. In a time when education even at the highest levels, tends to be focussed on the specifics of ever more complex disciplines, we should remind ourselves that as practitioners of public art and design, we are engaged in the centre of a social and political dynamic, which requires us to act in a connected and moral discourse. There is more to this than meets the eye. After a lifetime of teaching and working as a sculptor, I feel energised and uplifted to be so engaged. I am working in the heart of the dilemma of 'How do we progress?' A major part of my awakening to the reality of the action of Public Art and Design in the centre of society – essentially urban society – has been my experience of thinkers drawn together by the Public Art Observatory. I have become engaged beyond the immediacy of my working profession to the context of the function of cities. As professionals we must assume the responsibility which our privilege bestows to encompass 'eudaemonia' i.e. to deal with happiness. When we propose, design and draw up changes, can we be sure they will make things better? Samuel Beckett saw art as the means to refuse 'the refusal of the universe', to scratch our significance on the glassy granite of time passing; to record our humanness, and so in terms of the imaginary: our desires, our yearning, our pain to

return home and our nostalgia for 'things to be other than they are'. We have to be sure of the necessity for art.

> When I consider life, I am appalled to find it a shapeless mass... the landscape of my days appears to be composed, like mountainous regions, of varied materials heaped up pell-mell. There I see my nature, itself composite, made up of equal parts of instinct and training. Here and there protrude the granite peaks of the inevitable, but all is rubble from the landslips of chance.[12]

And in our time, we artists and designers, gods in our way, with our inventions, creations and plans, know what the city really is – industry, airports, internet, art galleries, libraries, and markets; stadia, tall technological buildings, banks and futures, and tourism and 'history' as commercial memory. The past is nothing except to tourists. The residue of the apparent past, farmhouses in Ireland and barns in England are more likely to be the second homes of rich city people who use the uniqueness that the 'historic' bestows to separate themselves from the commonplace of now. The landscapes of today are stage sets, largely preserved to feed our need to belong in the seamlessness of our present everyday, where everything feels the same except for the logo, emptily bestowing false identity. Where do we dwell? Genius, the highest accolade of human uniqueness, identified in an individual of unique mental power, gives way to research teams who quietly deal now with the complexities of medicine, the body, the truths of science. The heroes which we still need are purveyed to us by television through electronic revelations or prowess in sport – and the goods there paraded are mass produced. We buy and consume, then discard like leaves, as junk and polluting garbage long before use is exhausted. Greed and envy stoke the fires of capitalist consumer reality and the city is the great whorehouse of this mendacious culture.

Everything is debatable and complex. Sophisticated, loving care must be taken to 'do the right thing'. What is right? Whose rights – the viewer, the artist, the commissioner, the payer, the passer-by, those who stay, those who go? Art in public places has a record of blandness and compromise. The work by Richard Serra in Manhattan, 'Tilted Arc' being a case in point. It was commissioned by the General Services Administration, U.S.A. in 1981 who then, in 1985, removed it from the plaza in front of the Jacob K. Javits Building in Foley Square, Lower Manhattan, faced with the public outcry against it. For Serra, the prime attraction was "the very difficulty the site offered him"; for the public who used the square, it represented a monstrosity.

Art is a private activity engaged in by consenting adults – with a patron, public or private, as the active agent between the parties. Such activity in public as we have discussed is another matter likely to cause offence, in a society frozen in banality and mediocrity. The future demands the closer working partnership of artists and designers, within projects involving the real participation of business and the civic authorities, communities and public at large. The work of Cywaith Cymru throughout

Wales has engendered rich and diverse participation by key players. The art agencies of the U.K. have played a major role in developing new practice and of raising the awareness of partners. More has now to be done to take on the real issues.

Notes

1 Edouard Dujardin, *The Bays are Sere* Libris, London 1991

2 Ridley Scott, *Blade Runner* Warner Brothers 1982

3 Robert Browning

4 David Haley, *Writing – Water and Well-being project* Manchester Metropolitan University 2000

5 P Jukes, *A Shout in the Street* Faber and Faber, London 1990

6 'Paris 5' in *Architectural Review*, Volume 1133, July 1991

7 Marcel Certeau, *The Practice of Everyday Life* University of California 1992

8 ibid

9 Jonathan Raban, *The Soft City* Collins Harvell, London 1988

10 ibid

11 ibid

12 Marguerite Yourcenar *Memoirs of Hadrian* Penguin, London 2000

John Gingell
Lightpoint
Baglan 2002

Peter Knowles

a narrative

peter lord

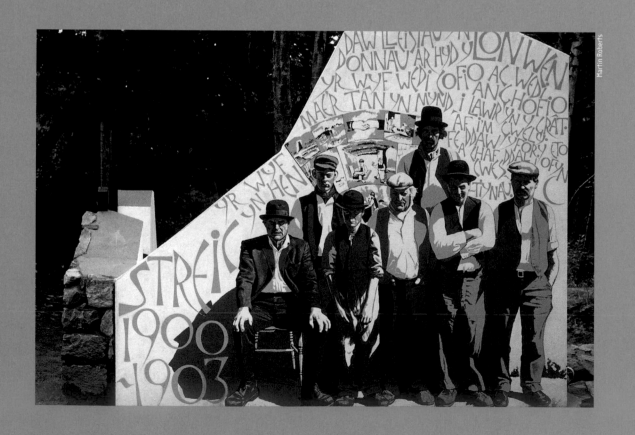

IN 1982 A GROUP OF PEOPLE met to choose a design for *Cofeb Hywel Dda* at Whitland in Carmarthenshire, among them representatives of the Welsh Arts Council and Carmarthen District Council, and the committee of local people who would be the commissioning body. I was not present at the meeting, of course – the process of selection was described to me much later. The group inspected several well presented sets of drawings, some from sculptors with established reputations. My proposal, in an unprepossessing A4 ring binder, was scarcely noticed at first. However, it gradually attracted attention because it was the only submission which presented a narrative of the event which the memorial was intended to celebrate. I am told that the local members came to feel that I understood the event in the same way as them, and I was commissioned. Considering their decision from the outside and twenty years later, I suspect that the pleasure which they took in the narrative itself was intensified by relief at the prospect of not having to defend to their fellow citizens the expenditure of public money on a vacuous object on a plinth. The narrative was to be related through a series of six gardens. Objections were likely to be few since the gardens would replace a decrepit cattle market in the centre of the town on a site surrounded by houses.

Nevertheless, *Cofeb Hywel Dda* proved to be the commission from hell. It became the focus of a bitter dispute for precisely the reason that the committee thought it would be attractive to the people of Whitland. The members failed to distinguish between the attractions of the narrative form and the potential for dissent created by the content of a particular narrative. The memorial was to celebrate the tradition that in the tenth century Hywel Dda, king of most of Wales, codified Welsh law at a place called Hendy Gwyn ar Daf, the Welsh name from which Whitland derives. The tradition is memorably recorded in a thirteenth-century manuscript, the text and illuminations of which provided the idea for much of the artwork, which was to be located within the gardens in the form of calligraphy, champlevé enamel plaques and brick mosaic pavements. The codification of law is indicative both of internal coherence among a people and of their distinctness from their neighbours. Early medieval Welsh law was constructed on fundamentally different principles from English law, which had been codified in Wessex a little earlier. Since the commissioning body had selected itself, most of its members were predisposed to welcome the national resonance of such a narrative. However, there was a second public in Whitland which was very ill disposed to a narrative of nationhood. Whitland lies in the parliamentary constituency taken by Gwynfor Evans, leader of

GWERIN Y GRAITH
Peter Lord
Mural painted by Wil Jones
Parc Glynllifon 1993

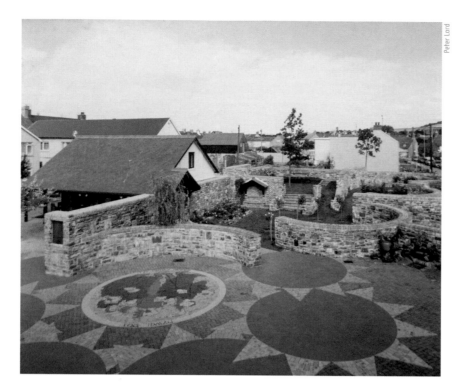

Peter Lord

Plaid Cymru, in 1966 – the first nationalist seat in Wales and a symbol bitterly resented by the Labour Party. A public park with a national narrative (from their point of view indistinguishable from a Nationalist narrative) was a very disagreeable prospect to most of them, an affront to their British sense of Welshness.

At first the construction of the memorial was slowed only by the minor impediments of uninterested and, in one case, possibly corrupt council officials who treated me like a benign idiot; one incompetent stonemason and another who, though able to lay stone, could not read a drawing; and the weather, which turned the site into something like Flanders fields. Public opposition to the project lacked a practical focus and so was confined to directing anger which bordered on hatred towards members of the committee, the workers and myself. The prime mover of the project, a resident of Whitland and an officer of Carmarthen District Council, died well before the memorial was complete. The gardener, who had come to Wales to find a less stressful life, returned to England. The more outspoken members of the memorial committee suffered years of abuse. A single incident illustrates my own experience. The site was adjacent to the dairy, the town's main employer. Many workers went home for dinner every day and walked past me as – on hands and knees – I was laying the mosaic pavements on what had been a narrow lane leading to the town centre. One man was in the habit of stopping every day, his feet in close proximity to my hands, and saying 'Why don't you fuck off back where you came from?'. This ritual persisted for the week or so that I was working on that part of the site. The thrust of his remark was not that I return to England, where I was born, but to Aberystwyth – Welsh Wales, and in particular Welsh-speaking Wales, as he dimly perceived it. Eventually a more practical outlet for opposition to *Cofeb*

Hywel Dda was presented to the objectors by the incompetence of council officers. I now realise that the opportunity was probably engineered by opponents able to exert an influence on those officers, whose reluctance to engage with the building of the memorial seemed to me inexplicable at the time. A central element in the scheme (pre-dating my involvement) was the closure to traffic of the lane which became the location of the mosaic pavements. While the work of pedestrianisation was underway the lane had been closed under a series of temporary orders. At a memorable meeting of the committee the Chief Executive of Carmarthen District Council announced (though so quietly that he had to be asked to repeat his statement), that there would be no permanent closure. The following morning many delighted local people drove backwards and forwards over the art work, some of them expressing their relish by honking their horns at me and the other workers as they went. The memorial, which they clearly perceived as a Nationalist icon, was defaced and members of the local Labour Party proclaimed a great victory for democracy.

Immediately after my appointment, in an attempt to bolster their confidence, the commissions officer of the Welsh Arts Council had written to the Hywel Dda Committee to assure them that they were in 'safe hands' because I was an experienced sculptor. This was untrue because at that time nobody was experienced at the kind of work involved at Whitland. It was unknown territory both because of its large size and its vague management structure, which was divided between the Committee, the Welsh Arts Council, the District Council and the sculptor. Four years later, having completed *Cofeb Hywel Dda* and three other projects, I could have been described as the most experienced sculptor in Wales at public art projects, which may

Left and Right
Peter Lord
Cofeb Hywel Dda
Whitland 1984

Iwan Bala

account for my appointment to design a scheme for a visual celebration of the literature of Gwynedd at Parc Glynllifon, near Caernarfon. As in Whitland, I took a narrative approach to the design. The literature of Gwynedd was presented as a story in the form of a series of sites, each related to a theme – children's literature, drama, the 'canu cenedlaethol' (patriotic poetry), 'gwerin y graith' (literature of the slate quarrying communities), and so on.

On the face of it there were few similarities with Whitland. There was no resident community around the site, which was enclosed behind a wall ten-foot high and seven miles long. The park had been the home of the Newborough family, the most powerful landowners in Caernarfonshire. The evolution of the Welsh Arts Council's commissions service into Cywaith Cymru was underway. The Arts Council funded the report but the Welsh Sculpture Trust was the body advising Gwynedd County Council, owners of the site. However, as I began work with my colleague, Delyth Prys, a worrying spectre of Whitland arose in the form of the mysterious internal machinations of local authorities. The project was largely the idea of the Chief Executive of Gwynedd County Council. He had the support of the Planning Department but it soon became apparent that together they were in a state of internecine strife with the Education Department, the occupying force in the park. Glynllifon housed their agricultural college and they resented the attempt which was being made to challenge their status as sole occupier. I therefore devoted a substantial part of my report to describing management structures which would resolve this conflict before it undermined the project. My recommendations were ignored, with pre-dictable consequences in both the short and the long-term. The immediate difficulty was that the design of the scheme itself was

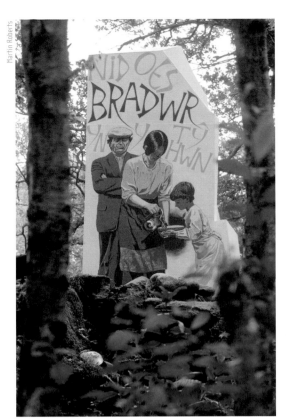

Left
Peter Lord
Cofeb Hywel Dda
Whitland 1984
Detail of tiles photographed 2005

Above
GWERIN Y GRAITH
Parc Glynllifon 1993
Peter Lord
Mural painted by Wil Jones
Ceramic jug by Morgen Hall
Bronze arm by Martin Bellwood

adopted only in part because the two departments would not co-operate. Only half of the sites identified for development were under the control of the Planning Department.

After the report was presented in 1986 I withdrew from the development of the scheme so as not to prejudice my position should I choose to apply for one of the site commissions at a later date. By 1992 two sites had been developed, though the second remained unfinished when I was commissioned (in competition with two other sculptors) to present schemes for *Gwerin y Graith*. This site had always been the one which I most wanted to design. When Delyth Prys and I began work on the outline scheme large areas of the park at Glynllifon were covered with dense conifer plantations, and much of the remainder had become a jungle of rhododendron and bramble. The remnants of the water features and sculpture created by various Lords Newborough from the late eighteenth to the late nineteenth centuries had to be discovered, like the ruins of Rome. One of the few routes open through the park ran from the house alongside the river Llifon at the bottom of a steep-sided and narrow valley. One day Delyth and I scrambled upwards beside a stream which descended into the dark valley bottom from the north. At the top we emerged suddenly into an open landscape of fields set against the distant background of Snowdonia. The tips of the quarries at Rhosgadfan were visible against the mountains. This was an unforgettable revelation. Rhosgadfan was the home of Kate Roberts and the

signs of life

robin campbell

FOR A COUPLE OF DECADES, the intensive redefinition of urban space has, given sufficient public and private confidence, allowed a growing understanding of the place for art and the art of place.

Although much of art which has been placed in public places has failed to realise its potential to challenge established aesthetic conventions, the boundaries of what can be achieved continually expand; cross-disciplinary collaboration between artists and other professionals is bringing about work which is not only aesthetically and conceptually challenging, but is meaningful to community, context and place.

In the case of Swansea, the rapid southerly shift of the city centre followed a goal (not yet achieved) of forming a direct pedestrian route from city to seafront. Part of the route is now in place; the newly reclaimed land parcels around the South Dock carried an obligation to promote art as intensification of route and bringer of incident. Several environmental interventions acknowledge place and people. The potential of art and craft in architecture was put to the test in a postmodern astronomical observatory, *The Tower of the Ecliptic* which saw a poet, sculptor, glass artist and calligrapher working with me to acknowledge the powerful spiritual role of a building whose purpose, standing at the edge of the world, was to be a bridge between our world and the worlds beyond; an eye looking out. The ascent up the four-storey spiral staircase to the largest telescope of its kind in Europe is topped with a glass oculus by David Pearl, ringed with dichroic glass, suggesting through the intensification of colour (purple/violet) that one is entering unfamiliar territory. The upper levels incorporate cantilevered balconies with fibreglass heads by Robert Conybear which symbolise observation and vigilance (now much more of a reality since the asteroid certainty emerged). The lower level incorporates six 'gnomic stanzas' by Nigel Jenkins which take the form of one of the earliest Welsh poetic forms, the 'englyn penfyr', which has a sequence of stanzas displaying incremental repetition, a characteristic of popular poetry and an indication of the public nature and location of the building. The stanzas are a means of handling scientific matter and at the same time of making reference to human behaviour.

By 1990 the city had established the first 'percent for art' programme in Wales; the public art programme was moving back into the city centre, much more a daily part of public ritual than the reformed docklands. A series of collaborations between poets and visual artists were producing proposals for a wide range of 'municipal graffiti' and environmental artworks, all responding to aspects of history and identity. The desire to

David Hughes
Ambition is Critical
Pavement piece
Swansea Railway Station 2000

113

make marks, to celebrate, educate, politicise, curse, amuse and advertise has given text a rightful place in our environment, whether as a mark of establishment or of the forces of oppression. (Byron's autograph on a classical Greek column is now a tourist attraction, after all.) New environments and urban regeneration are ideal opportunities for messages, poetry and text to compete with the estimated 6,000 urban advertising slogans with which we are faced today. The flowering of urban graffiti in the 1970s led to calls to ban the sale of aerosol spraycans to those below the age of eighteen, and set the stage for a more considered role for urban text. The timing of these collaborations coincided with Swansea winning the bid to be 'City of Literature' in 1995 (and, just possibly, made the case for the reward). The first stages of the city centre project were completed, including site-penned poetry by Menna Elfyn. In the 1980s a republican observation had appeared on one of the main bridges leading into Swansea – Caesar hasn't a clue what's going on – and was duly noted down by Nigel Jenkins, one of the 'municipal graffiti' poets. Through discussion and development this took on the local dialect 'Seezer Avena Clew Wots Gowin On', and was fused with a tribute to the fact that the Romans seemingly had made copious detours around Swansea – a stage set steel fragment of a Roman arch. A treated steel streetwork in celebration of Victorian photographer Richard Calvert Jones was also planned, where, at certain angles of the sun, a representation of one of his photographs would appear in shadow. However a virulently hostile press campaign, acting on malicious rumours and leaks drastically curbed the collaboration, and both works were dropped, thus seriously compromising the notion of a public art which can explore significant questions of contemporary cultural discourse. While the artists and poets were producing work in celebration of the local dialect, the local press raged that it was 'taking the piss out of the local patois'. One piece, a directional fingerpost by Nigel Jenkins which read 'Remember Tomorrow' had a street life of 28 hours, and the 'City of Literature' was heralded by a municipal scrapyard for removed texts.

Media venom was then directed towards Will Alsop's prize-winning design for the National Centre for Literature; with no apparent civic confidence to defend the design, it was scrapped, later to appear in a modified form at Peckham Library, where it won the Stirling Award for Architecture in 2000. A series of vox-pop street interviews conducted by a local newspaper and the vilification of cutting-edge architecture is very likely to have seriously damaged confidence in the economic future of the city.

Some work escaped the scrapheap. Possibly the most-visited piece of public art in Wales is a pavement piece by David Hughes which confronts travellers arriving at Swansea station reading 'Ambition is Critical' which sought to cleanse the well-known malediction of Swansea being 'the graveyard of ambition', which has not exactly helped inward investment over the years. The pavement poem formed the focal point of the confusing opening dialogue of 'Twin Town', the movie set in Swansea. Critically, the text can only be read by those entering the city,

rather than leaving.

The creative engagement of art and architecture can bring about a clarification of identity. But let's remember Peter Eisenman's distinction between 'building' (a verb) and 'architecture' (a noun) – 'Building is about serving function; architecture is about serving art'. Much of our urban landscape built over the last quarter century is comprised of the former. The nightmare scenario for many artists is to be introduced to a project where the 'building' is nearing completion, the landscape design has been agreed, the means of site lighting and signage finalised – how to recover the loss?

In an effort to investigate a more meaningful collaboration, I established apART with sculptor Brenda Oakes in the late 1990s. The collusion has produced several hybrids, which explore the relationship between structure, ideas and space. The shortlisted proposal for a Birmingham Tower was submitted in a competition to celebrate the British building industry on a site at the NEC. The structure takes the form of a curved 30 metre light steel and timber wing, topped by a chromed RSJ, from which was hung a 20 metre illuminated compression drum covered with a flexible skin, suspended over a pool. The internal perspective of the drum was revealed as a reverse image in the pool. The geometry of the 'electronic crossing' grew from a study of source geometries of domes and lanterns in architecture. apART was commissioned to submit a design for a street art project in Dorchester, sited in what turned out to have been a vast Neolithic timber henge, 380 metres in diameter and built of some 500 oak trees. Discussion with the archaeologist who had led the partial excavation suggested that the Neolithic engineers were, in building the henge, creating a better economic environment, bringing about peace between previously warring tribes, and celebrating the beauty of landscape. The design responded to the context by proposing natural elements of purbeck stone, slate, oak, elm and rowan, steel and water, placed around an 'electronic town crier', which would allow townspeople to contact each other, receive civic messages and relieve the (very hard-pressed) human town crier.

The crafting of architectural structure, surface and space, and the demystification of many building processes through recent TV programmes has widened the perception of what can be achieved in a building conversion or with new build. The artist-craftsperson has a real and increasing role to play in the hand making of unique or original artefacts, which can extend the nature and meaning of space. Swansea's Environmental Resource Centre (2000-2001) has a crafted roof structure with a green roof, supported on locally sourced green oak columns. The process of fashioning the ends of the columns led to a chamfered, wet rope-bound detail, which tightened as the rope dried, and limited the splitting of the green oak as it dried out. Sculptor Roger Moss has echoed the verticality of the oak colonnade with recycled aluminium door handles, cast from ash saplings at MB Fine Arts.

The differentiation of sites and the ability of the artist not only to tap the social and cultural qualities of place but also to

Iwan Bala

become the agency of recovery and metamorphosis are central to his or her response. The particularisation of the nature of place in an industrial park presents rather larger problems than normal, urban sites. Stripped of many of the established socio-cultural associations, Baglan Energy Park occupies a flat landscape overlooking the Bristol Channel where a beautiful tension exists between the natural landscape and the industrial complex, with adjoining scrapyards, abandoned docks, a recently-established gypsy site and an elevated section of the M4 as neighbours. For the last half century this has been one of the largest oil refineries in Wales. Changes in oilfield production have led to its closure, anticipated in 2006. As the pipes, tanks and cooling towers disappear, a new infrastructure of industrial sites and access roads is being established. The 650 hectare site is programmed by the funders Neath Port Talbot District Council, Welsh Development Agency and B.P. Chemicals as an ecologically diverse, mixed use quality environment serviced by an advanced combined gas turbine which provides cheap power. A recently adopted public art strategy seeks to memori-alise the night-lighting of the old refinery while promoting the use of renewable energies.

The intention here is to bring together the properties of the place – its architecture, massing, huge skies, and flatness, tied together around a framework of lightworks and groundworks which follow and undercut the previous industrial grid. The cohesive feature takes the form of a 'light spine'(conceived while taking off from Toronto airport on a clear winter night), itself consisting of several works of differing intensities and values, and giving spatial determination across the site: a sign of life. It has implications of a sighting (ley) line, or a track (as opposed to a street) – it might recall movement patterns predating cartography, such as the great lines at Carnac or Kennet, the

Apula and Bora passageways of the Aborigines, where rites and rituals can have physical expression on the landscape, and stories told in visual images or placed objects or signs can reinforce the spirit of the Dreaming. The light spine, in the Welsh context, has the ability to tie down myths, rites, dances and music to place or places on the spine; it can provide an account of the human predicament at the basic level by forming a passageway to the sea: a twenty-first-century version of 'walking the line'. On a functional level it can provide windbreaks, viewpoints, picnic areas, skateboard ramps. A series of sight 'light markers' will define entrances, interchanges and limits.

The first commissioned piece, 'Light Point' by John Gingell, was placed in 2002 to signify the entrance and northern gateway to Phase Two. The 22 metre steel tower incorporates a two metre vertical axis wind turbine providing 24 watt energy to illuminate the circular upper section with low energy LED lamps, wired to a computer which will dictate the colour programme and its responsiveness to weather patterns. 'Light Point' thrusts towards the sky – from which it derives its energy. Glowing at night with the captured energy transformed into colours which form the constituents of white light, it has already become an identifiable landmark. Placed adjacent to the tower built by Brunel to house the hydraulic lift mechanism for the old dock basin, 'Light Point' celebrates that great engineer's innovation to harness energy more effectively, typifying the aim of the energy park.

Future stages will shadow emerging green technologies by bringing artists to work within the adopted framework to engage in meanings that add intensity, vigour and a new particularisation of place, even if it is not art-like.

Roger Moss
Left
Roof trusses
Right
Sculptural door handles
Environmental Resource Centre,
Swansea 2000

making sense of it – artists

and rural communities

stephen west

Deborah Jones

"WINTER. WHAT SHALL WE DO OUT IN THE COUNTRY?"
Alexander Pushkin.[1]

> The Welsh and the English, the Welsh-speaking and the English-speaking, the proper Welsh and the not so proper Welsh, the insiders and the outsiders, the Italians, the Poles, the Irish, the Asians and the Africans and the likes of us, all fighting amongst ourselves for the right to call ourselves Welsh and most of us losing out to some very particular idea about who belongs and who doesn't. How would we ever make sense of it?
>
> from *Sugar and Slate* by Charlotte Williams 2003.[2]

Residency projects in rural locations are very popular with artists. Advertising these projects in rural Wales sometimes leads to an overwhelming application from British, international or Welsh artists. A proportion of these artists are Wales-based and generally they are very successful in being appointed. This is not just an accident of geography, but also an indication of the depth of experience that Welsh artists have built up over the years in rural and environmental artworks. Indeed, it is the sense of closeness to the land and fitness for a place that must be one of the uniquely important qualities of Welsh art. Some of the credit for developing the level of site-specific and community experience of Welsh artists can go to Cywaith Cymru and its earlier incarnation, The Welsh Sculpture Trust, for the innovative projects that it has managed in every corner of Wales over the last 25 years. It would be fitting if this rural expertise could be reflected in any new museum of contemporary Welsh art, even though such an institution may be urban-based.

Discussion on rural arts has become focussed in recent years, with research projects running in universities and with conferences, such as those organised by the rural arts organisation Littoral, helping to map out a role for artists in the context of increasing problems in farming and other rural industries, in the Rural Shift conference, and in Wales the 'Culture in Agriculture' seminar organised by Menter a Busnes or the Galleries and Rural Communities seminars of Engage Cymru. Much of Wales has a rural-based culture, particularly in north, mid and west Wales, but even the industrial valleys of South Wales retain a closeness to farming and the land. Government policies through local authorities have been focusing on rural

COED Y BRENIN
Deborah Jones
Marking the Wind
Trawsfynydd Primary School, May 2002

regeneration and issues of jobs, health and transport and rural isolation. It is true that one of the largest sectors of employment in rural areas is the arts and culture and rural-based artists have much in common with the beleaguered farming community; they work as a vocation rather than just for economic reasons, they are usually self-employed, have to be self-sufficient and often work in isolation and for low incomes. One direct link between art and agriculture was made in Pip Woolf's drawing residency at Brecknock Museum, where she engaged with isolated farms during the 2001 foot & mouth outbreak through a drawings-by-post project based on tools and the use of land. Based in Montgomeryshire hill farms in 2003, the exemplary *Making Sense* residency will be described in detail further into this chapter.

Other projects that have brought contemporary artists into contact with communities across north Wales in recent years include the artist-in-residence programme on Bardsey Island, which ran for a series of summers with different artists responding to the unique environment and population of this small island off the Llŷn peninsula. One of the largest projects was the Slate Valleys Initiative in Gwynedd which involved two lead artists and numerous others in communities in the Ogwen, Nantlle, and Peris Valleys and the areas around Blaenau Ffestiniog and Corris; this as part of a larger programme to regenerate tourism in former slate quarrying communities. In the summer of 2002 the Visitors Centre in Coed-y-Brenin hosted two artist's residencies highlighting the growing role of Forest Enterprise as contributing to local culture and society. An interesting project also ran in Beddgelert with the artist Rawley Clay making works referring to some little known as well as renowned local histories and in the process becoming the indisputable 'village' artist.

Cywaith Cymru and Gwynedd Council worked with sculptor Meical Watts in 2000/01 and Dominic Clare in 2002/3 on the ambitious Slate Valleys Initiative footpath project. The foot-paths pass through and link villages and places of interest as

well as linking in to the public transport system and national foot and cycle networks. All five Welsh-speaking areas have a rich industrial heritage and were slate quarrying communities in the past, with both rural and industrial aspects to their culture. Tourism now plays an important role but the development of these pathways is to enhance the experience for local people as well as the tourist industry. Schools and members of the communities took an important role in the development of the artworks. Slate was worked in a variety of ways, with letter cutting, relief carving, drilling, painting, water jet cutting and sandblasting all being used to create text and image on a scale from a few inches to several metres. Some incorporate wood, metal and reclaimed objects. The artists used both traditional sculpture techniques as well as adapting industrial methods to the production of work.

Coed-y-Brenin is a forest of 9,000 acres near Dolgellau, which was purchased by the Forestry Commission in 1922 and extensively re-planted. Historically it was part of the Nannau Estate founded by Cadwgan, Prince of Powys in 1100 AD. Recently it has become world renowned as a mountain bike centre with over 40 miles of purpose-built cycle tracks and a dual-slalom course. The bikers and other visitors are catered for at the Visitors Centre at Maesgwm where there is a bike parts shop, café and bike wash. This was selected as the focus for the first artist-in-residence project at Coed-y-Brenin. An essential ingredient was the co-operation of the Visitors Centre run by Sian and Dafydd who are both outdoor sports specialists and well-known to visitors and residents alike. Coed-y-Brenin connects Cader Idris and Dolgellau to the south via the wetlands of Crawcwellt to Trawsfynydd and Snowdonia in the north. Inland are the Arenig Mountains and Bala and to the west lie Barmouth and Tremadog Bay. The forest has a history of gold and copper mining and religious sites and it now has a reputation as one the foremost cross-country biking centres in the world. There are walks and nature trails and wonderful wildlife habitats. Maesgwm is also the site of the computer

left
SLATE VALLEYS
Meical Watts
Blaenau Ffestiniog 2000

right
COED Y BRENIN
Deborah Jones
Ganllwyd Primary School 2002

controlled sign making facility for Forest Enterprise with state of the art routing machines that can cut and colour virtually any design to any depth of timber. Two artist's projects were initiated, the first with a very open-ended brief where research, interaction and listening were the highest priority and a second, which would result in the installation of work in the woods next to the Visitors Centre. Connectivity in time as well as space and the use of sound became central to both these projects

Deborah Jones, a Welsh artist now working in Bristol, spent much of her residency working with Hedd Wyn Primary School in Trawsfynydd and the local Ganllwyd Primary School. During school visits to the forest she worked with the children on ideas of mapping the landscape, listening to the landscape and recording impressions in drawing and words and activities in the landscape such as walking, den-building, fighting, hiding and playing. The river and the 'glay' (a clay-like substance) found in its banks featured strongly, as did the midges. During this time she also asked mountain bikers, pumped-up with adrenalin after coming off the trails, to contribute drawings of their experiences. These chinagraph drawings on acetate, which also featured the midges as well as various bike parts, falls, cuts and scratches, formed the content of books left in the café. They also became the designs for the final artwork of this part of the residency, 40 trays, routed-out in the sign shed with designs from the bikers' drawings, inlaid with various colours for use in the café. This simple but effective work involved all the people at Maesgwm in a collaborative project, which included research into materials, contact with the local Milliput factory in Dolgellau and the co-operation of staff on the computer and routing machines.

Following on from Deborah's project, Pippa Taylor worked in wood to make large-scale musical instruments, children and adults being able to contribute and to learn the joinery and musical theory that goes into these works. Again the sign making and forestry facilities were essential, selecting and cutting timber that would be long lasting and resonant from the timber stocks or from the trees in the forest. Some oak was selected for the schools' workshops but local douglas fir was used on site. A wooden marimba was designed, tuned and constructed in the first part of the project with Barmouth School, the making being done in small groups who sawed, chiselled and drilled to make and decorate the marimba and the beaters and helped to tune the instrument. The scale used was the five-note pentatonic scale found in African and Far-Eastern music. This showed that very young children when well supervised in small groups can achieve accurate carpentry with sharp tools.

Pippa worked on the larger-scale instruments; three log drums or slit drums and a larger marimba, on site at Maesgwm, involving day visitors. The log drums are vertical sculptures carved from single logs, their tops carved and coloured with wood dye and the interiors of the drums chain-sawed out and charred. Heavy sticks are used to beat them and they are also tuned to different notes. Forestry staff at Coed-y-Brenin made a wheelchair-accessible path to a new intimate site amongst trees, rocks and moss where the large marimba and drums are

Stephen West

Stephen West

COED Y BRENIN
Tuning and making
Activities led by Pippa Taylor
Artist-in-Residence 2002

Stephen West

installed. On a slope facing the bowl of the Afon Eden valley the hollow musical sound of wood on drum and wooden keys joins the sounds of forestry workers, birds and the occasional shout from a mountain biker.

In a very different, almost treeless environment (apart from the famous Enlli apple), we have been sending artists over the short but unpredictable sea crossing to Ynys Enlli (Bardsey Island) just off the tip of the Llŷn Peninsula, in what has been a wonderful opportunity for each of the artists who have been resident there. Now owned and managed by the Enlli Trust, the island was once part of the Newborough Estate and the farm architecture shows that heritage. It is a wildlife and plant sanctuary with rare seabirds and seals sharing the rocks, has a lighthouse and a sheep farm; also a fishing island and a place of pilgrimage where, it is reputed, 20,000 saints are buried. Electric power is rationed, running water a luxury in some dwellings and toilets vary greatly from home to home. In many ways the way of life on the island is nearer to the nineteenth century than the twenty-first.

In 1999 Trudi Entwistle stayed in the lighthouse keepers' cottage, one of the most modern on the island. She made temporary artworks that were interventions with slates and sticks, an installation with fishing buoys and a 'walk' of cut bracken on the mountain. Islanders and summer visitors (on holiday or on scientific research projects), appreciated that a contemporary artist could make work about the environment but with no lasting physical effect. Ben Stammers, a locally-born Welsh-speaking artist, stayed in 2000 and made photographs that, when digitally edited and combined, used the abstract elements of colour found in commonplace objects to make up large scale prints. That year almost every local 10/11-year-old schoolchild on the mainland (over 1,000 in number) visited the island's artist; going on walks sketching and collecting images with Ben.

The following year, Clare Barber's residency, based in the cobbled stable near the church, referred directly to two of the most important cultural aspects of the island. The leaving of the

Trudi Entwistle

Left
COED Y BRENIN
Log drums, Maesgwm
Pippa Taylor
Artist-in-Residence 2002

Above
BARDSEY ISLAND
Trudi Entwistle
Artist-in-Residence 1999

last of the flock of Welsh sheep was remembered in a series of felt slippers made for children and a unique 'Cloak for Watching Stars' was also made from the last of the fleeces and hangs on a peg for use by future star-watchers. The burial of 20,000 saints was referred to by the title of her residency 'A Day for Stepping Lightly' and in the swings that she constructed so that she could move around her stable accommodation without treading on the ancient floor This was a kind of six-week live performance that included another swing in one of the many legendary caves around the shores of Enlli. Performance formed part of Susan Adams' 2002 residency as well, but in a different way, as she made string puppets from carved driftwood and inhabitants of the island became players in a series of paintings of important real and mythic characters from the island's history.

The fifth Enlli artist in residence was Lois Williams, who referred directly to the relation between language and women's work. The floor installation, which she included in her work in the stable, expressed the struggle for language to communicate at the same time as holding cultural significance. The twisted tar and rope forms began to take on the appearance of an alphabet.

All these artists have been profoundly affected by their residencies on Enlli and the project will have a long-lasting

Ben Stammers

YNYS ENLLI/BARDSEY ISLAND
Left
Trudi Entwistle
Zig-Zag
High Tide
Artist-in-Residence 1999

Above
Ben Stammers,
Untitled photographic triptych
Artist-in-Residence 2000

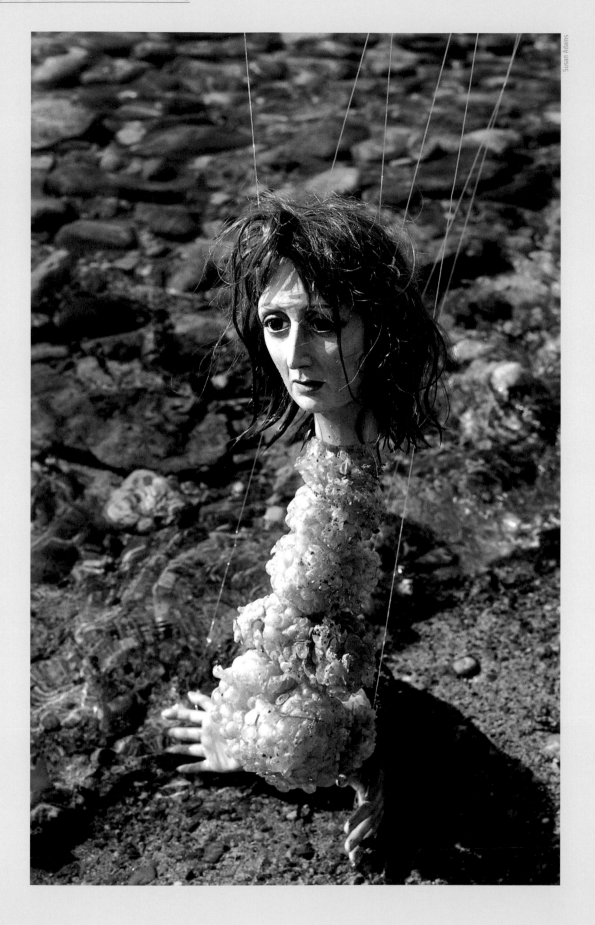

Susan Adams

YNYS ENLLI/
BARDSEY ISLAND
Susan Adams
Life of St Isonia
Artist-in-Residence
2002

Clare Barber

Clare Barber

YNYS ENLLI/BARDSEY ISLAND
Clare Barber
Left
Ogof Trwyn yr Hwch Swing
Above
A Day for Stepping Lightly
Artist-in-Residence 2001

Duncan Edwards

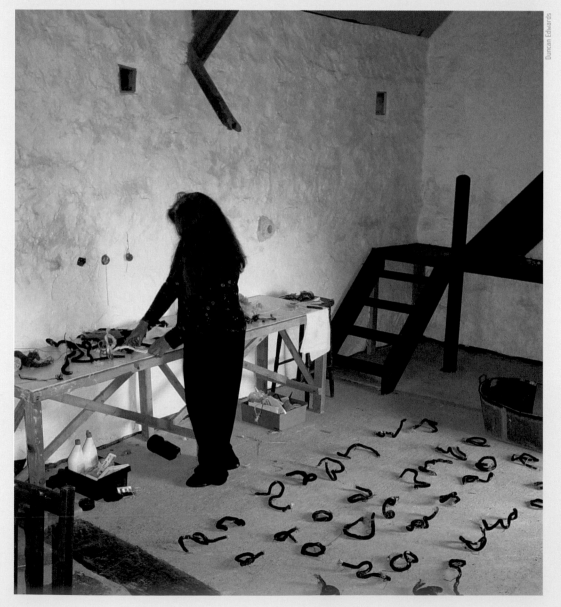

Duncan Edwards

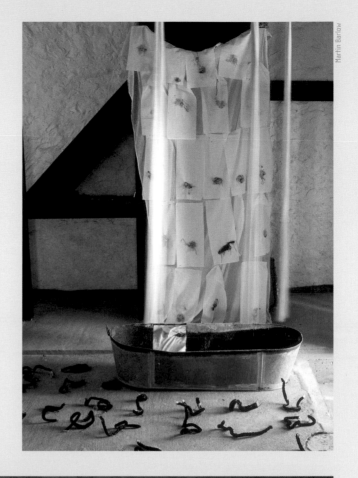

Martin Barlow

Duncan Edwards

YNYS ENLLI/
BARDSEY ISLAND
Lois Williams
*Small Ceremonies,
Small Realities*
Photographs of work
in progress
Artist-in-Residence
2004

effect through works and memories left on the island and through the involvement of Oriel Plas Glyn-y-Weddw and Oriel Mostyn Llandudno in exhibitions and educational events.

While some artists become habituated to the unpredictable life of the residency artist it is also true that a residency can be an once-in-a-lifetime experience. The involvement with a community which might be contracted as a fixed period can become indefinitely extended. Contacts made and works started can lead the artist into an unofficial role as friend, art advisor and consultant; or the spirit of place can get into his or her soul, profoundly influencing subsequent work. A poetic and visionary quality can be found in transient works such as the 'Cloak for Watching Stars' on Enlli or the dreamlike sequences of horses in Jony Easterby's projected video intervention at the 2002 'Equilibre' performance in Powys. Iwan Bala has written about Rawley Clay's residency in Beddgelert (literally Gelert's Grave):

> he integrated into village life, he really became the village artist. He began to see himself as an itinerant, yet fully functional social element, bringing some kind of cohesion into the community.[3]

For his project, Rawley lived in (and stencilled poetry on to) an abandoned forest hut, and diverted a stream in one window, over his bed and out through the front door. Another resulting artwork is the bronze dog in a derelict sheep-pen: a memorial to the hound Gelert, whose story gave the village its name. This one residency treated the village to the familiar and expected as well as the experimental and visionary.

Cywaith Cymru started discussions with two partners in 2002; the National Eisteddfod Arts & Crafts Committee and the National Museums and Galleries of Wales particularly with the Museum of Welsh Life, St. Fagans. By putting together sufficient funding and developing a brief that allowed a substantial period of research and contact with the local community together with a notion of collecting – objects, sounds, stories – we were able to

Tamara Krikorian

Rawley Clay,
Left
Gelert
Bronze sculpture
Above
Intervention in chalet in
woods above Beddgelert
Artist-in-Residence
Beddgelert 2002

commission artists who would 'make sense' of the opportunity
afforded by the Eisteddfod coming to a small rural community
around Meifod, Maldwyn and the Marches. The artists appointed
were Carlos Pinatti, a Cardiff-based Spanish-speaker originally
from Argentina and Christine Mills, a Welsh speaker from the
Banwy Valley. They are two artists from very different cultural
backgrounds, or, as Ken Brassil of the National Museum termed
it, 'the local and the exotic', and they brought a combination of
adaptability and rigour to their working methods and strategies.

Based in a small studio in Llanerfyl they started a period of
research on material in the collection at St. Fagans such as
Abernodwydd, the farm house from Llangadfan transported to
St. Fagans. They researched the harpist Nansi Richard, and
looked at video, sound interviews, musical instruments and old
books of farm ear tags or 'nodau clust'. They worked both
separately and together, sharing skills and learning new skills to
push the project forward to the urgent deadline of the
Maldwyn Eisteddfod 2003 – and all of this with the constant and
lively input of ideas and specialist skills from the local
communities. There were visits and workshops in a number of
primary schools, sessions at the young farmers rally, sessions
with poets and local storytellers in the Cann Office Hotel and

Stephen West

Stephen West

Stephen West

Stephen West

numerous visits to farms and fields. In addition, visitors to the studio were encouraged by continuing coverage in *Plu'r Gweunydd*, the local Papur Bro. This meant that plenty of material was available to the artists to sift and consider.

The themes of 'Communication & Identity' emerged and evolved both literally and metaphorically as the project progressed. By focusing on links to hill farms which had their own unique pitch marks or sheep ear tags and pursuing the idea of identity through field names and writings about place, the artists arrived at poetic ideas relating to how a farmer identifies his animals through markings or how a ewe whose lamb has died may be tricked into bonding with an orphaned lamb by 'coating' it in the dead lamb's skin. A child embracing and being welcomed into a new identity and culture is also symbolised by a little green felted coat with embroidered words of Welsh hanging on a school coat hook.

These ideas coalesced into a multi-media installation outside and inside the Art & Craft Pavilion in Meifod involving video film, music, felted and dyed woollen garments and cases of objects both new and old collected and curated by the artists. It also included, presented in a museum case, a new artists' book titled *Murmura Maldwyn* made in a unique collaboration with the Gregynog Press. This book included combinations of written texts and lists of field names with transparent overlays of sheep ear tag designs, all contained in a special binding, protected by a hessian enclosure and in a box lined with details of an eighteenth century map of the land. The farms lie in an area from Cwm Nant-yr-Eira through Mathrafel to Pen-y-Bont-Fawr, a land resonant with history but living and working in the year 2003. Ten additional

CREU SYNNWYR/MAKING SENSE
Christine Mills and Carlos Pinatti
Artists in Residence
National Eisteddfod, Maldwyn 2003

books were made by Gregynog Press and have entered the collections of the National Library, National Museum, Bangor University and the Contemporary Arts Society for Wales.

At the Engage Cymru seminar discussing 'Tackling Rural Isolation', Robyn Tomos, Visual Art Officer for the National Eisteddfod, spoke rather of the positive aspect of 'tapping into rural expertise'. The project resulted in contemporary artworks as important, artistically and culturally, as anything being produced in the cities. It is possibly relevant that, in the first years of the twenty-first century, radical politics and protest have moved from the urban and industrial to rural issues of transport, identity and use of land.

One could not leave a discussion of rural arts projects in north Wales without mentioning the Dingle near Llangefni in Anglesey where there has been such a focus of site-specific sculpture and temporary artwork. Tim Pugh is vastly experienced in temporary environmental work in Britain and Wales and has extended his ways of working in residencies in Australia and Tasmania, where he experimented with pigmented drawings on rocks and trees. These transpose to the intimate setting in the Dingle where charcoal drawing of Welsh maps on the bark of trees lasted well through storms and snow. Ann Henderson, from the tiny Rathlin Island off the coast of Northern Ireland, worked with women and children from the local women's refuge to make an animated digital work reflecting the tiny details of the woodland floor and showing that the latest technology can be used in just as sensitive and telling way as ancient sculptural and drawing techniques. Residencies at the Dingle, in collaboration with Oriel Ynys Môn, have run alongside a sculpture commission programme, just as at the nearby Tyddyn Môn Farm, and can involve people in speculative and experimental visual work which will prepare and interpret themes used in larger permanent public art.

People involved in rural visual art residencies can have a truly eclectic experience. It is interesting how well the newest media works alongside the traditional in rural situations; how some artists can adapt to plugging in a computer in the local church hall or sharing equipment with inexperienced participants with exciting results. It is tempting to imagine that the focus on cities, the centres for innovations in art for the last couple of centuries, may give way once more to the nourishing of culture and civilisation which can take place in tiny rural communities in the first century of the new millennium as it did years ago in rural centres such as Strata Florida, St. Davids or Valle Crucis. Life in the countryside is no more or less 'real' than city life, yet the projects I have described show that residencies in rural communities can have fresh, truthful and unpredictable outcomes which may be difficult to achieve in established urban institutions.

Notes

1 Alexander Pushkin,1829 (tr. A.D.P .Briggs)

2 Charlotte Williams, *Sugar and Slate* Planet, Aberystwyth 2003

3 Iwan Bala, *Here + Now* Seren, Bridgend 2004

Tim Pugh
Top
Dingle Diversity
Bottom
Charcoal Rituals
Dingle, Llangefni 2002

poets and
evangelists_____

simon fenoulhet

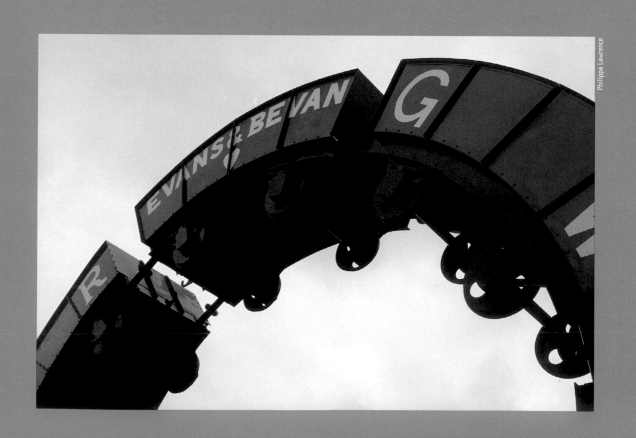

Philippa Lawrence

Andy Hazell
Wheel Of Drums
Hengoed Viaduct 2000

PUBLIC ART IS SUCH A WORTHY SOUNDING TITLE for something that should be a life-enhancing addition to the norm. It has the ring of something utilitarian rather than the poetic we might aspire to and tells us that it's done in the public's name and presumably for its benefit. And it is this idea of public benefit, the thing that the Arts Lottery claims to measure in assessing grant applications, that contains the seeds of mediocrity. Like it or not, it has become very fashionable to commission artists to create works for all manner of public spaces in our towns and cities and even into the countryside. It has become part of our expectation rather than the surprise it once was and the danger, of course, is that public art becomes part of the furniture of every day life in a way which might rob it of its ability to question and to provoke.

The last fifteen years has seen a particular change in attitudes to public art amongst those responsible for planning our public spaces. No longer is it a question of justifying the presence of art in the public realm, it has become the rule. Planners and developers more often than not have funds and sites allocated to public art as one of the ingredients that they hope will make their development a success.

However, at a time when there are more opportunities for artists to work in public, it does not necessarily follow that those opportunities are more interesting, more highly developed or take more account of the full range and complexity of what artists have to offer. So while it is expected that artists will play a role in the development of our public spaces, there is only a marginally more sophisticated view in the market place about what artists do.

Some have argued that public art has helped to rehabilitate the artist in the public psyche since the post war separation of fine art from other areas of design. While it is true that the public at large are more likely to know and appreciate some public works of art, I would suggest that the opposite is true, public art gives a very limited soft-focus window onto the world of art as every work that has made it onto the street has been through a filtering process that has usually ignored the extremities of art practice and firmly occupied the middle ground. This is an inevitable consequence of funding art through committees with access to the public coffers and reflects the desire of those responsible to spend that money prudently. And that is the conundrum: the inherent conservatism in that

process is, by default, the filter through which public art must pass in order to be accepted.

The role of the public art organisation has therefore changed from one of persuasion, inclusion and evangelising as there is a continuous demand for pubic art. No longer do we have to convince people of the value of public art, the new challenge is to broaden the scope of what exists in the public's imagination when the term public art is used. The fact that public art is an accepted part of the street scene also means that planners, councillors and the public at large already have prejudices and predilections firmly in place. To the sophisticated it usually means a reliance on names, famous names of artists who already have a number of works in Britain's major cities. But a lack of knowledge is no bar to opinion and I have often heard people say they'd like to commission a work like one they saw elsewhere. It's as if there's a fear of starting with a clean slate, a blank page, because of that leap into the unknown. But it is the only way to start, by looking at the context, the setting, the social fabric and the historical resonances in order to describe what might be possible.

Given the very pragmatic nature of working in the built environment, occasionally the engineering of major structures offers an aesthetic challenge. From the very outset, Cywaith Cymru has sought to create opportunities that have enabled artists to work alongside other design professionals such as architects, landscape architects and engineers. Having negotiated a place for the artist to be a part of the design team, they are then able to become an integral part of the process, challenging accepted conventions, applying their knowledge of materials and incorporating themes and ideas that will add another layer of complexity, symbolism and meaning. Engineers have turned out to be willing collaborators, especially as they see a clear line between their skills and the artist's. Somehow this artificial division of the functional and the aesthetic is fertile ground for collaboration, allowing a blend of poetry and pragmatism to be shared. And it mustn't be assumed that all the poetry belongs in the artist's domain. If the collaboration is successful, then the honours are shared.

A good example of this is Jon Mills' work on the design of the new bridge over the River Dyfi. The time he spent with the Powys Council bridge engineer, Bruce Pucknell, enabled him to develop the already elegant cable stay design into something more poetic. His analysis of the main elements of the design, the vertical pillars and the curving balustrade led him to make fundamental alterations which rendered them more dynamic, less abrupt, and more in keeping with the rural surroundings. The real interest here is the sharing of skills and abilities by individuals that allows new forms to be developed. Jon brought his sculptural sensibilities and knowledge of working with metal to a very practical problem. Working with an engineer allowed him to turn the bridge into an object that responds to its surroundings, delights the viewer and lifts the practical into the poetic.

The triumph here lies in the amalgamation of the two skills. The artist could not have designed and built the bridge on his

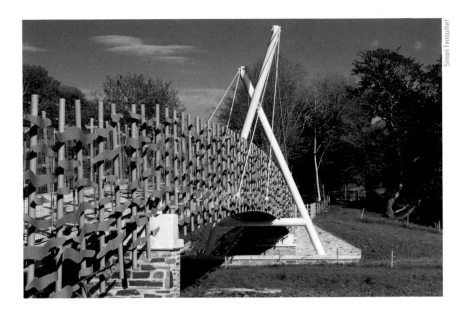

Simon Fenoulhet

own and the engineer could not have conceived of its aesthetic, but together they have created a beautiful synthesis of their respective skills. It is not enough to talk about the artist altering the look of the bridge. What he has achieved goes beyond the passive appearance and alters our experience of the bridge as you encounter it and use it to cross the river, the public's relationship to the landscape is affected, knowing that the bridge is unique and particular to this place it becomes a powerful memory of place.

The crucial factor is the ambition with which the project was conceived. Ambition is difficult to define and even more difficult to instil in others but it's the key to persuading people of the value of what is being attempted and ultimately, in getting it paid for. This bridge was always intended to be a landmark statement, a millennium project that would go far beyond the mere necessity of getting from one side of the river to the other. In fact, the bridge forms a key link in the National Cycle Network, allowing cyclists and walkers to take an alternative to the narrow and dangerous road bridge between Machynlleth and the Centre for Alternative Technology a few miles to the north.

The development of the National Cycle Network has opened up a wide range of routes to cyclists and walkers alike. This opening up of our byways has increased access to some spectacular scenic routes as well as encouraging the use of traffic-free routes for the daily commute to work or school. Sustrans has always had a policy of commissioning public art as a part of their route developments and Cywaith Cymru was always keen to work with them to identify opportunities for artists as more routes were opened up throughout Wales.

The thinking behind commissioning artworks along the cycle network is a recognition that the routes are mostly for leisure cycling and walking and are therefore somehow at one remove from the normal road or street. This distance allows for a far greater freedom in imagining what works might be successful in these semi-hidden locations. The works take many forms,

Jon Mills
Dyfi Millennium Bridge
Machynlleth 2001
Engineer: Bruce Pucknell

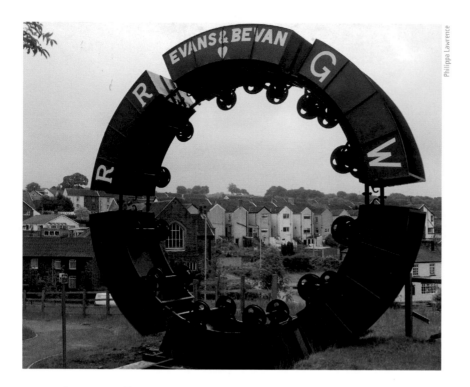

Philippa Lawrence

sometimes small wayside sculptures, sometimes entrances and gateways that mark the start of a part of the route and sometimes landmarks that signify an important location or junction. When the Hengoed viaduct was refurbished and incorporated into the national network, this superb stone structure quickly became an important pedestrian link between the villages on either side of the valley. Its re-birth was marked by a decision by Sustrans, Caerphilly County Borough Council and Cywaith Cymru to commission a landmark sculpture at its eastern end to celebrate both its previous and present use. Sculptor Andy Hazell was recruited to develop a series of proposals which (with the help of public opinion) resulted in the 'Wheel of Drams' sculpture being created for a prominent site. This giant steel ring stands some eight metres high and is formed by six curving trucks in recognition of the coal and ore companies that sent their goods to port over the viaduct. The work has become an emblem of change, where one tradition is overwritten by new ideas. The heavy goods for which the railway was built are now a memory while the superb engineering of the viaduct lives to serve a new purpose.

The open design competition is the mechanism by which most Cywaith Cymru projects are selected, not restricting the shortlist to artists already known, but allowing any who want to apply the opportunity to do so. This is more than a straightforward act of fairness. It offers a direct unfiltered view into the artists' world, allowing people to see a wide range of work and be directly involved in creative choices from the outset.

The obvious advantage is that the work of a wider number of artists is viewed, many of whom would not have emerged otherwise. Interestingly, most clients prefer to throw the net wide rather than relying on the near at hand, and if in the end, the local artist is selected, then it's for all the right reasons. This

Andrew Cooper

was exactly the case with the design for the gas holder in Llwynypia when a nationwide competition led us to Cardiff-based glass artist Andrew Cooper.

The 120-foot-high gasometer had long been considered an eyesore when Cywaith Cymru was approached by the local authority to consider how it could be improved. Their concern was that this rusting industrial relic was standing in the way of their attempts to promote the area as a place for businesses to locate to. (Actually, perceptions of the gas holder varied somewhat as we were to discover.) The opportunity was advertised throughout the U.K. and drew a wide response from experienced mural artists, painters, sculptors and others, with over 70 outline proposals for a possible treatment. From these initial ideas, five artists were shortlisted to develop detailed designs, which had to include a method for the design to be applied. Andrew Cooper's design had been developed after a visit to the site had revealed the gas holder standing against a wooded hillside. This autumn scene provided the colour palette for the design as photographs of the site were pixilated and collaged to create the system of squares that make up the design. Embedded in this approach is the solution to its application, as breaking the design down to a series of squares of solid colour allowed a foolproof method for contractors to apply the design.

The result was a fiery explosion of unexpected colour that stood like a beacon on the road to Treorchy. In this simple way, a monolithic remnant of an old and outdated industry was re-invented and became a symbol of change in the valley. The public exhibition and consultation we had carried out had prepared the ground locally and there was little opposition to the project, only the news media sought to criticise the project but it must be said that the vox pops were in our favour. Sadly the gas holder has since been demolished.

Left
Andy Hazell
Wheel Of Drams
Hengoed Viaduct 2000

Above
Andrew Cooper
Gas holder
Llwynypia 1993

A lot of public art has been commissioned in the cause of regeneration and it has proved to be an easy bandwagon to board, extolling the virtues of art and craft in helping to re-brand town X or Y. Regeneration isn't in itself a reason to commission artworks and not every regeneration scheme is an opportunity for an artist. The schemes that work best are the ones where artists contribute to the whole thinking, working alongside planners, landscape architects and highway engineers to define their respective responsibilities as well as areas where their work overlaps.

Most of these projects have been landscape led but the one at Tonypandy is an exception. The initial impetus came from the Highways Department's desire to pedestrianise the High Street. Working with landscape consultants McGregor Smith, sculptor Howard Bowcott was selected to collaborate with landscape architect Tim Rose to define the extent of the pedestrianised area and to try and develop a legible identity for this newly created public space. Closing the road and stopping the traffic is no small feat in a town that relies a lot on passing trade. The right mixture of by-pass and parking has to be provided to encourage people to use the town. On top of the engineering works, what ought the finished street look like?

Bowcott's role was to help develop a narrative thread that informed the design of the whole street, drawing on the town's history as a mining settlement. There were discussions with special interest groups like the Chamber of Trade, the Civic Society, the local comprehensive school and the elders of the Bethel Chapel whose frontage was at the centre of the pedestrianised area. This unscripted talking process helped to set the theme, looking at it from the geological perspective of how the coal came to be there in the first place, as well as the human experience of mining the infamous 2'6" coal seam that ran underneath the town and the living memories of the hardship that entailed. The location of the Chapel proved to be an advantage in that it offered an opportunity to open up the street to create a public square, provided that the chapel elders consented. Howard's designs centred on that area with a proposed sculpture made from the local pennant sandstone and referencing the coal seam with a 2'6" block of black coal-like material at eye height, with a symbolic shaft that penetrated down through the stonework. He also proposed inscribing a poem on either face of the sculpture to help develop the narrative element and involved the elders in choosing the text. In an unexpected turn of events, the elders liked the idea of bringing the chapel into the public realm to create a town square on their frontage but rejected the poetry texts on the grounds that they were too negative and encouraged the artist to look elsewhere. As a result, Gillian Clarke and Menna Elfyn were commissioned to write poems in Welsh and English especially for the sculpture.

The scheme is particularly successful because it manages to synthesise the artwork into the fabric of the street, with Bowcott's sculptural references finding themselves embedded into the benches, tree grilles, litter bins, bollards and paving,

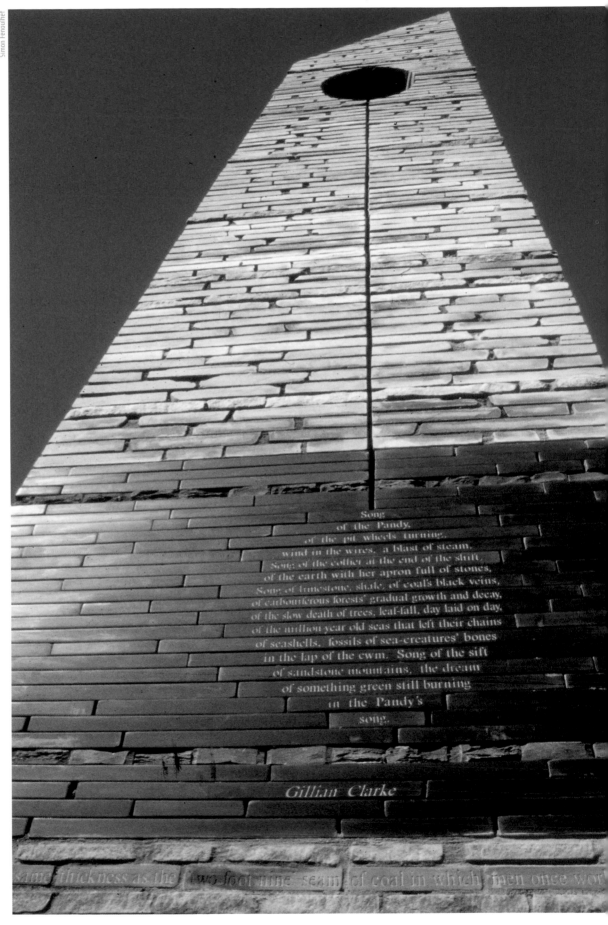

Simon Fenoulhet

Song
of the Pandy,
of the pit wheels turning,
wind in the wires, a blast of steam.
Song of the collier at the end of the shift,
of the earth with her apron full of stones,
Song of limestone, shale, of coal's black veins,
of carboniferous forests' gradual growth and decay,
of the slow death of trees, leaf-fall, day laid on day,
of the million year old seas that left their chains
of seashells, fossils of sea-creatures' bones
in the lap of the cwm. Song of the sift
of sandstone mountains, the dream
of something green still burning
in the Pandy's
song.

Gillian Clarke

...and thickness as the two foot nine seam of coal in which men once wor...

Howard Bowcott
Memorial Column
Tonypandy 1999

leaving imprints of plants and animals from the carboniferous period throughout the street. It also exemplifies the process of discussion that results in a more sensitive response from the artist.

The larger proportion of the work that Cywaith Cymru does results in projects of a permanent or semi-permanent nature. It seems that there's a clear link in some people's mind between cost, longevity and value. True, a lot of the work is conceived as some kind of urban enhancement, which has to take its chances along with the other street furniture and which therefore roots it in the same 'procurement' mentality, subject to the rigours of Best Value. In the gallery, impermanence is the rule and the public expects the contents to change regularly. This is a long way from happening in our towns and cities.

The exceptions to this have only come about because of Cywaith Cymru's own interest in creating opportunities for artists above and beyond the permanent work and without the constraints of a residency where the process may be somewhat proscribed. Whenever opportunities for artists to exhibit out of doors, or to create temporary site-specific work have been advertised, the number of applications has been overwhelming. A clear signal that there is a tremendous hunger among artists for this kind of project.

Naivety is sometimes a useful quality. Without it we would never have proposed a major exhibition of stone sculpture in the rugged terrain of Powis Castle in mid Wales. *Stoneworks*, as it became known, was a joint enterprise with Oriel 31 (now Oriel Davies) in Newtown and sought to display something of the development of stone carving in Britain in the post-war period. In spite of the major undertaking of transporting a vast tonnage of stone from the four corners of the country and siting the bulk of it in a fairly inaccessible woodland, the show was a great success in bringing sculpture to a wider audience.

More recent developments in exhibiting outside the gallery have focussed on creating new work rather than historical surveys. Whether as a response to a lack of opportunities in the

Simon Fenoulhet

Eric Gill
Carved Garden Roller
STONEWORKS, Powis Castle 1988

Helen Jones
Three Elemental Vases
Gregynog Sculpture Exhibition 1992

gallery sector or a desire to move art away from the increasing commodification of art, there has been a shift in favour of environmental art. I use the term environmental here to encompass the idea of context as well its green connotations, with artists making work for a place and of a place. Working at Gregynog Hall in Powys gave five artists the chance to make artworks in response to the mixture of formal and informal landscapes that surround this architecturally-challenged building.

The idea that environmental art is by definition environmentally neutral was dispelled by Helen Jones' *Three Vessels*. Three giant bowls were created using a compound of resin mixed with salt, carbon and earth and sited on the carefully mown lawns near the house. The vessels, each a metre across, collected rain over the weeks that followed and played out their own environmental experiment with dramatic consequences. The salt vessel remained a sterile and hostile environment for anything that fell into its clear saline contents, killing insects and killing the delicate grass around its base whilst standing unnaturally white and pristine against the green lawn. The carbon vessel seemed rather more neutral in its impact, allowing the grass to grow around it and catching rainwater that birds could drink from without fear of poisoning. The earth vessel was a micro culture all its own, supporting plants and insects in profusion. The murky soup that had collected inside was a breeding ground for micro organisms that in turn attracted insects and then no doubt birds to feed on them too.

This object lesson in material interaction was an interesting example of how the context informs the work, leading the artist

Richard Harris

Richard Harris

Richard Harris

Richard Harris

Richard Harris
Walking with the Sea
Earthwork
Llanelli Millennium Coastal Path 2000

Mick Petts

to challenge the garden aesthetic and make a work that reveals a more aggressive and divisive view of nature than the one offered by the idyllic site in which it is placed.

Some of the most exciting opportunities have come about through the reclamation of redundant industrial sites which have been brought back into the public realm. The most ambitious example of this is the Millennium Coastal Park at Llanelli where a strip of land stretching from the Loughor estuary to Burry Port has been reclaimed, landscaped and redeveloped to create a mixture of open space, housing and protected habitat.

From the outset, Cywaith Cymru was part of the team of consultants employed to develop the masterplan for the site. Embedding an arts strategy in the overall thinking at this stage made it possible to appoint artists to work on each of the design team areas as they were developed. At the eastern end of the site, the Wildfowl and Wetlands Trust already occupied an important area of protected wetland. The appointment of Mick Petts, with his experience of environmental art, landscape work and habitat enhancement, led to a vast range of creative interventions within the Wetlands.

The most obvious is his collaboration with architects Acanthus Holden on the design of the hide which overlooks the largest of the numerous lakes. The front of the building is clad in layered oak planking which echoes the pattern of a bird's flight feathers. From the elevated approach, the building's secret is kept until you enter the central doorway and come into the hide with its panoramic views over the water. The use of oak and the soft outline of the building and its setting ensures that it is a sympathetic addition to the landscape, in spite of its dramatic appearance. Its prominent location and bold design make it a powerful emblem, a celebration of the diverse birdlife that it is

built to observe. From inside the hide, the view itself is also part of the artist's vision. The edges of the lake follow a pattern of ridges that form fingers of land that reach out into the water. Petts' study of the surrounding estuary landscape revealed similar patterns left in the mud which he transposed to the lake to bring that reference to the fore. The benefit is more than aesthetic, as the jagged shoreline dramatically increases the amount of land in contact with the water to the advantage of the plants and insects that colonise the water's edge. This in turn helps to attract birds to feed at the site, in a way that combines functional and aesthetic concerns. A combination which is borne out of the artist's own training, knowledge and interest and which is able to flourish in this setting.

In works of this kind, the boundaries between disciplines are blurred and definitions of artform become redundant, obliging the viewer to look at the site in a way that suggests artifice can be both as functional and as aesthetically pleasing as nature. After all, in creating a new landscape, who is to say what is real, imagined or artificial? In a climate where specialism is so highly valued, the artist offers an alternative, non-verbal way of analysing the world. Mick Petts' approach allows for a free association between sculpture, landscape and habitat creation.

Further along the coast, a more abstract and seemingly prosaic set of issues confronted Richard Harris, working with Mott MacDonald, consulting engineers. Their design area contained land contaminated by a former power station that once served the nearby steelworks. The fact that this scarred landscape needed to be completely re-modelled held its own creative potential. Once the toxic materials had been removed and the land stabilised, the profile of the landform was a matter of debate/choice. With no necessity to re-instate the original contours, Richard was able to start thinking about the landscape without preconceptions. Using the outline of the existing headland as his starting point, he designed a giant earthwork of converging terraces that meet as if at the point of a breaking wave. The work can be experienced from the perspective both of viewer and participant, since the public are able to veer off the coastal path that passes close by to follow the arc of the wave. The terraced earth also serves to protect a small bay created to the east, sheltered from the prevailing winds. In cradling this small area of sandy beach, the work also draws the viewer's attention to the headland, a welcome relief to the eye at the end of a long straight stretch of coastline.

The danger in only viewing a photograph of the work is that it is read purely as an abstract earthwork, a geometric imposition on the landscape. In reality, its success lies in the experience it simultaneously affords, as landscape, and as sculpture.

Looking back over an eleven year span of commissioning at Cywaith Cymru reveals an interesting trend for artists to be invited back into the public domain. In some cases it may be because of individual artists demonstrating what they can contribute but more likely it is due to a lack of meaning in our public spaces that drives all of us to want to inject creativity, meaning and human warmth into our streets and squares. Modern manufacturing and

Mick Petts
Heron's Wing
Gateway Hide
Architects: Acanthus Holden
Wildlife and Wetlands Centre 2000

153

construction so often removes all trace of the individual that there is a huge appetite for works by artists that reveal the originality and invention of the human mind.

Cywaith Cymru still oversees the commissioning of the monument and the monumental but the ambition is to create a range of projects that embrace a wider cross-section of artists, aiming to expose the public to all kinds of temporary and permanent work, mainstream, experimental, practical and dangerous. This calls for a fluidity and flexibility in the approach to setting up projects to prevent them following predictable paths.

Public Art agencies have to take a catalytic role that encourages others to see the creative potential locked within their scheme and to resist the temptation to define the artist's role too closely until that potential has been fully explored. This is the essence of the role, leading lay people into the rich variety and complexity that underlies our visual culture, letting them see what artists do rather than restricting them to what they can already imagine.

When the Welsh Arts Council set up its commissioning service in 1981, it did so with the laudable aim of being a neutral broker between the artist and the client. The fundamental aim was to stimulate a market for public art which would have the dual benefits of bringing the work of living artists to a wider public as well as allowing artists another source of income that might help to support their practice.

What it couldn't have predicted was the creation of a sub-genre of art that crossed over into urban design, landscape and architecture and in so doing has gained a much greater influence on the look of our towns and cities. Artists create paving design, walls, railings, seating and signage. Maybe this need for things to be embedded is part of the Zeitgeist and will be a good thing in the long term but I can't help mourning the loss of the individual work of art.

It is increasingly necessary to question the motives for commissioning public art, otherwise the reasons for promoting it so vigorously in the first place may be lost. Those reasons are not to commission great street furniture or yet another memorial, but to find a role for artists to have a voice outside of the confines of the gallery. The real reason to employ artists is not to decorate our streets with emblems of prosperity, but to embrace a multiplicity of viewpoints, value their creativity for its essential visionary qualities and to engage with the power of originality.

Top
Andy Rowe
Sundial
Porthcawl 2001

Bottom
Andy Hazell
Thumbprint
Detail, nightime
Swansea Police Station 2002

David Symons

Mererid Roberts

O DRUM
HYD DRUM
PATRYMAU
O RWD
AC AUR
WEDI U
GWAU

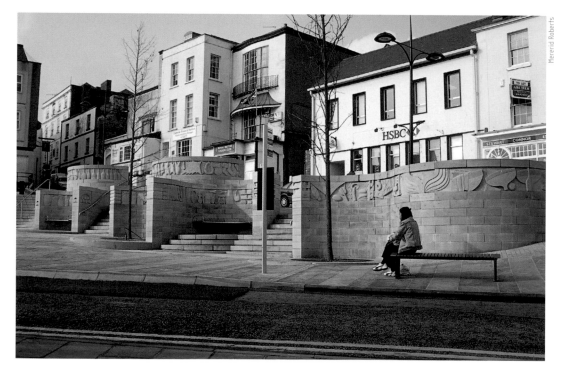

Mererid Roberts

Mererid Roberts

Tamara Krikorian

Left
High Street
Redevelopment
Chepstow 2005
Top
André Wallace
Boatman
Tim Shutter
Spheres
Bottom
Howard Bowcott
Turret Frieze
Right Top
Catrin Jones
Newport Market Window 2003
Right Bottom
Richard Harris
St Non's Stones
St Davids Visitor Centre 2000

index